IRISH ART NOW: FROM THE POETIC TO THE POLITICAL

IRISH ART NOW

FROM THE POETIC TO THE POLITICAL

Declan McGonagle Fintan O'Toole Kim Levin

Merrell Holberton Publishers, London

Independent Curators International, New York

in association with the Irish Museum of Modern Art, Dublin

Published in conjunction with the traveling
exhibition **Irish Art Now: From the Poetic
to the Political**, organized and circulated by
Independent Curators International (ICI),
New York. Guest curator for the exhibition:
Declan McGonagle.

Exhibition Funders:
The Foundation-To-Life, Inc.
The Cultural Relations Committee of the
Department of Foreign Affairs, Dublin

Transportation assisted by Aer Lingus Cargo

Aer Lingus ☘
Cargo

Exhibition Itinerary:*

McMullen Museum of Art
Boston College
Boston, Massachusetts
October 3 – December 12, 1999

Art Gallery of Newfoundland and Labrador
St. John's, Newfoundland, Canada
January 30 – April 9, 2000

Chicago Cultural Center
Chicago, Illinois
Summer 2001

* at time of publication

First published in 1999 by Merrell Holberton Publishers Ltd
and Independent Curators International

Produced by Merrell Holberton Publishers Ltd
42 Southwark Street, London SE1 1UN

Distributed in the USA and Canada by Rizzoli International
Publications, Inc. through St Martin's Press,
175 Fifth Avenue, New York, NY 10010

Edited by Julian Honer
Designed by Peter B. Willberg at Clarendon Road Studio, London
Printed and bound in Italy

British Library Cataloguing in Publication Data
McGonagle, Declan
Irish art now : from the poetic to the political
1.Art, Irish 2. Art, Modern – 20th century – Ireland
I.Title II.O'Toole, Fintan, 1958–
709.4'15

ISBN 1 85894 089 3

Photo Credits:
The Irish Museum of Modern Art, Dublin,
and the artists

Cover:
Alanna O'Kelly, **Sanctuary/Wastelands**, 1993
(video still, detail; see Plate 31)

Table of Contents

7 Foreword and Acknowledgments

9 **Renegotiating the Given** Declan McGonagle

21 **Ireland** Fintan O'Toole

27 **Poetics, Politics, and Irish Art:**
Thirteen Questions Kim Levin

36 Dorothy Cross
40 Willie Doherty
44 Mark Francis
48 Ciarán Lennon
52 Alice Maher
56 Caroline McCarthy
60 Fionnuala Ní Chiosáin
64 Abigail O'Brien
68 Maurice O'Connell
70 Alanna O'Kelly
72 Kathy Prendergast
76 Billy Quinn
80 Paul Seawright

85 Artists' Biographies
91 Checklist of the Exhibition
96 Independent Curators International, Board of Trustees

Reflecting the seismic changes in Ireland's political, social, economic, and cultural realities during the last decade of the century, contemporary Irish artists are redefining traditional identities, raising questions about the relationships between male and female, urban and rural, North and South, history and the present. This struggle over identities that used to marginalize Ireland and societies like it has now become central to current cultural debates around the globe. This book and the exhibition it accompanies present a reading of Irish art of the period and examine the repositioning of Irish identity with works drawn mostly from the collection of the Irish Museum of Modern Art, Dublin, an institution that was founded just at the start of this momentous decade.

The project brings together works by younger as well as more established artists, most of whom live and work in the Republic of Ireland or Northern Ireland. Their questioning voices reflect a dialogue within their society and contexts beyond Ireland, using painting, photography, sculpture, video, and installation to explore subjects ranging from the personal and poetic to the political. They share a basic understanding that the languages they use cannot be regarded as innocent carriers of meaning but must be seen as an integral part of their subject. These concerns—and the way they are conveyed through non-traditional materials and new interpretations of more conventional media—link these works to new art being made today elsewhere in the world.

This book and traveling exhibition have been made possible with the encouragement, dedication, and generosity of a great many people. First and foremost, we extend our warmest thanks and appreciation to the artists whose work we are proud and gratified to present. We would also like to express our high regard to Kim Levin and Fintan O'Toole for their articulate and insightful essays that enrich and expand our understanding of the works in the exhibition and of the Irish society of the 1990s in which these works were created.

On behalf of the Board of Trustees of Independent Curators International and the Board of the Irish Museum of Modern Art, we would like to express our sincerest thanks to the generous sponsors of *Irish Art Now* who share our vision for this project and who have made generous contributions to help make it possible. We are grateful for the support of the Foundation-To-Life and the Cultural Relations Committee of the Department of Foreign Affairs, Dublin. In addition, we are indebted to Aer Lingus Cargo for their assistance in transporting the exhibition.

Many individuals on the staffs of ICI and IMMA have contributed their professional skills, their creativity, and their enthusiasm to the production of this publication and exhibition. In this regard, we want to express our appreciation to the following ICI staff members: Carin Kuoni, Director of Exhibitions, and William Stover, Exhibitions Associate; Angela Gilchrist, Director of Development, and Douglas Gatanis, Development Associate/IT Manager; Jack Coyle,

Registrar; as well as Elizabeth Moya-Leiva, Executive Assistant, Ava Crayton, Development Assistant, and Jennifer Kay, Exhibitions Assistant; and the following IMMA staff members: Catherine Marshall, Head of Collection; Brenda McParland, Head of Exhibitions; Ronan McCrea, formerly Assistant Curator, Collection; Sarah Glennie, Curator, Exhibitions; Ellen Rowley, Exhibition Coordinator; and Marguerite O'Molloy, Assistant Curator, Collection. We are pleased that their efforts have resulted in an important and timely exhibition. This distinguished catalogue was produced by co-publisher Hugh Merrell and his staff at Merrell Holberton, London. We wish to thank them all for their creative collaboration. The exhibition is accompanied by a comprehensive filmography of recent documentary, feature, and animated films and videos that address a multitude of political and social issues specific to Ireland at the close of this turbulent century. For this contribution we are indebted to Sheila Pratschke, Director, and Sunniva O'Flynn, Curator of the Archive, of the Film Institute of Ireland, Dublin.

In addition, we would like to acknowledge the generosity of the following lenders: Green on Red Gallery, Kerlin Gallery, and Temple Bar Gallery and Studios, all in Dublin; Bugdahn und Kaimer Galerie in Düsseldorf, Germany; and, of course, the artists. We would also like to thank Caroline Alexander of Alexander and Bonin, New York.

Working with all these people to bring the many parts of this collaborative project together has been a rewarding experience for all of us. To everyone who recognized the importance of this exhibition and publication and gave generously in so many ways to ensure its success, we express our appreciation and gratitude.

Judith Richards
Executive Director
Independent Curators International

Declan McGonagle
Director
Irish Museum of Modern Art

Renegotiating the Given

Declan McGonagle

The work in this exhibition comes primarily from the collection of the Irish Museum of Modern Art in Dublin, the first national institution in Ireland concerned with the collecting and programming of contemporary and modern art. The museum opened in 1991 and its identity and development owe much to the forces that have also conditioned the practice and ideas of artists in the exhibition.

The museum is housed in the first and finest classical building in Ireland, built in the late seventeenth century as a home—a place of hospitality rather than of medical care—for pensioner soldiers. The Commander-in-Chief of the British Army in Ireland was also the Master of the Hospital. The museum therefore inhabits a multi-layered, important, historical, and highly charged context.

In fact, much of the political and social terrain we inhabit in Ireland at the end of the twentieth century was first articulated in the period of equivalent political turmoil at the end of the seventeenth century when the Royal Hospital was built. With its architecture of classical order over native disorder the building and its new role as a museum of modern art is now linked directly to that issue of the renegotiation of cultural/political positions that is underway in Ireland and is reflected in this exhibition.

Relationships between Catholic and Protestant, North and South, Ireland and England, and Ireland and Europe, which were more or less established in the late seventeenth century and have persisted ever since, are now being reconfigured as Ireland, in a new European context, renegotiates its historical sense of self as victim. The artists in this exhibition are beneficiaries of that renegotiation, but they are also increasingly effective contributors to the present process of change. Change has been particularly marked over the last decade or so and is reflected in the work of Irish artists who, whether living in Ireland or elsewhere, have found their voices or have matured in the period from the late 1980s into the 1990s.

As a new national institution, the Irish Museum of Modern Art has positioned itself in the present, and a founding principle is that only current works by living artists are bought for the collection. Although there are no quotas in terms of gender, subject, media, race, or nationality, this has resulted in the museum now having a particularly strong body of recent work by a group of Irish artists who reflect in their ideas and practice a panoramic sense of Irishness that includes interaction with the world.

These artists do not form any sort of formal grouping, nor do they share a manifesto in relation to art, Ireland, or their identity, but they seem to me to draw on the same reservoir of meanings associated with being Irish and being artists in the world.

This link is crucial in reading these works. For previous generations of Irish artists the idea of Ireland *in* the world would have been a contradiction in terms and with little structural

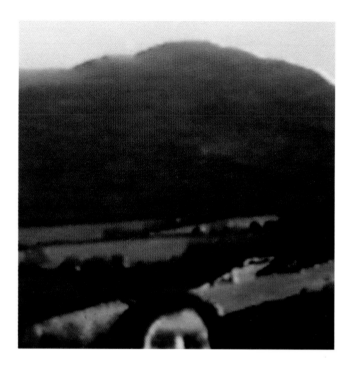

support, an impossibility for them to achieve in reality. Many Irish artists therefore took James Joyce's advice and became silent, cunning, or went into exile. The last ten to fifteen years, however, have seen seismic changes in attitudes in Irish society and culture that are consciously reflected in many works in this exhibition. The exhibition treats the poetic and the political as polar positions in a cultural/social continuum and argues for an ahistorical reading of this art in particular and, by extension, of art in general. The exhibition, therefore, must not be read as an attempt to create a definitive survey of all Irish art but as an exploration of a particular moment of cultural shift with social and political inflections. It is polemical, partial, and, most importantly, provisional. This text represents my particular reading of the art and its position in this exhibition which acknowledges, and indeed insists on, the need for other readings to follow.

The core of the exhibition is the body of work from the collection of the Irish Museum of Modern Art—in a sense statements already made and collected by the museum since the early 1990s—to which more recent works have been added from the artists' studios. The works are diverse—some made to describe experience, others made as a result of experience. They represent key points of interaction between the visual arts in Ireland, in this particular period, and visual arts activity elsewhere.

One of the clearest articulations of that interaction is in the video work of Caroline McCarthy, one of the youngest artists in the exhibition. *Greetings* (Plate 22) involves two video monitors with archetypal images of the Irish landscape, into which, every now and then, the head of the artist intrudes at the bottom of each monitor screen. As a young Irish woman at the end of the twentieth century, McCarthy is saying that she has no purchase on this

Caroline McCarthy
Greetings, 1996 (video still, detail)

landscape of meaning, which is part of a deeply implanted and widely projected sense of Ireland as a site of nature (God-given) rather than of culture (man-made).

This reading of the Irish landscape that McCarthy finds impossible to enter is a product of disempowering colonial projections of Irish reality, which McCarthy and her generation simply do not accept. In *Greetings* she represents it as problematic, a process that has to be negotiated and cannot be accepted as a given. The title of her piece refers directly to the period in the past when heavily idealized postcard images of Ireland were bought in their millions by tourists and sent to family and friends "back home." This contributed to a powerful and lasting projection of an innocent and nostalgic Ireland that also defined the country's sense of self over a long period. This Ireland was offered up to outsiders and it is this automatic association of the land and ruralism with a claim on the truth of Irish national identity that McCarthy recognizes as being problematic in her piece. Caroline McCarthy is now working in London, where she has made *Journey through the Longest Escalator in the World* (Plate 21), drawing on her everyday experience of the subway in London. The work involves a typical transformation of a commonplace object—a dishwashing-liquid bottle—into a (space) ship of folly that travels endlessly and pointlessly, arriving nowhere. McCarthy's works are absurd as well as unsettling. They do not seem to fit within any given set of meanings. The artist is as wary of the cityscape's claim on truth as she is of the nostalgic landscape. The video monitor on which the image plays, when installed in a gallery space, is placed above head height, referring to a subliminal feature of contemporary man-made urban spaces—closed-circuit television and the tentacles of social control.

This concern with landscape is central to other works in the exhibition, including those by Alanna O'Kelly, Willie Doherty or Paul Seawright. In the work *Longing/Lamenting* (Plate 4), Doherty provides two emblematic images of land and sky overwritten with the word "Longing" on the bright-blue sky and "Lamenting" over the image of grass, an unambiguous statement that landscape is ideological, that we constantly project meaning on to nature and that this has been a particularly visible and damaging feature of the Irish situation. Doherty's other photoworks in the exhibition, *Incident* and *Border Incident* (Plates 5 and 6), present images of two burnt-out cars at the side of narrow country roads. When one is aware of the origins of the context of the artist and his imagery—information one inevitably receives in an art context before experiencing the works themselves—there is a presumption that these are simple images of violence. The title of each image plays with the viewers' expectations, with the word "Border" adding a sense of local conflict. In fact, one car had been burnt out as part of the process of dumping it—for "domestic reasons," as it were—but the other car had indeed been burnt out after having been used in a paramilitary action close to the border between Northern Ireland and the Republic. It is our reading of the totality of the material that invests the objects depicted, which are more or less the same, with meaning.

The subject of these photographs and of Doherty's work in general is the construction of meaning in our minds as viewers and readers of images and information. Meaning is not fixed

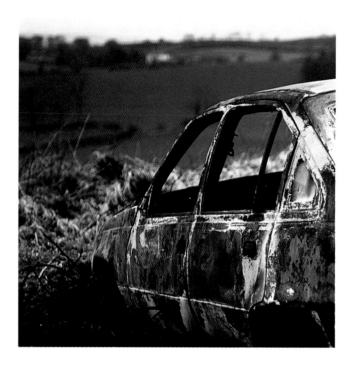

or absolute, least of all in the photographic images and information of the mass media that Doherty reveals and counterpoints. Northern Ireland has been the subject of much media attention and cultural comment over the years because of the drama of the Troubles, but the "truths" thus communicated are heavily conditioned by the means through which the information is received and, indeed, by our own origins from which we come to that information. The tension between representation and reality is reflected in Doherty's regular use of double images in his photographic or video projection works, such as *The Only Good One is a Dead One* (Plate 7). In a way, he is saying that there are at least two, if not more, sides to every story.

Paul Seawright is another artist who uses photographs and the properties of photography to reach behind the surface of the Northern Ireland situation and to create images based on the phenomena and the by-products of the drama. He has photographed the unsentimental interiors of police stations and security installations. Such exaggerated installations and environments were commonplace throughout Northern Ireland and these were the spaces where policemen and soldiers spent their working lives. Seawright records these environments and shows that they were also brutal and brutalizing, although unseen and unrecognized by the public.

The caged doorways to pubs in Belfast (*Cage I* and *Cage II*; Plates 39 and 40), which were constructed as protection so that people arriving could be seen on security cameras before being admitted, are manifestations of the more visible brutalization of civilian society and activity in both Protestant and Catholic communities in the North, where the abnormal

Willie Doherty
Border Incident, 1994 (detail)

became normal. The third image of a rusted and dilapidated metal gate (*Gate*; Plate 38), which, coincidentally, takes the form of the Union Jack flag, was found in the Peaceline in Belfast. The Peaceline structure has evolved into an elaborate Berlin Wall-type barrier running across flashpoint areas between opposing communities. But Seawright's images could also refer to any extreme urban environment where civic society has lost its cement and has been brutalized and disempowered, perhaps by economics if not by political or religious division. His new Cibachrome works, "Fire Series" (Plates 41 and 42), deal with the scorched earth left after ritualized bonfires, which are lit, mostly in Protestant communities, to mark and celebrate key dates in the calendar of the Protestant/Loyalist identity. Part of Seawright's enquiry, from someone with a Protestant background, is about his own community's position in the Irish context as articulated in defense mechanisms and defensive celebrations—dramatic and convincing in their theatricality but, as Seawright shows, desultory and banal in their reality.

There are strong connections in both Doherty's and Seawright's work with the current use of lens-based media in art in general and the apparently non-judgmental projection of the banal and commonplace.

The sense of community widens with Abigail O'Brien's key work *The Last Supper* (Plate 29), which addresses the role of women and gender issues. It is debates around these issues that, over the last twenty years or so in Ireland and internationally, have questioned the idea of singular authority and maleness. O'Brien also confronts a Catholic hegemony in Irish society and replaces the male apostles at the Last Supper with women in a tableau, which is fronted

Paul Seawright
Flag, from Fire Series, 1998 (detail)

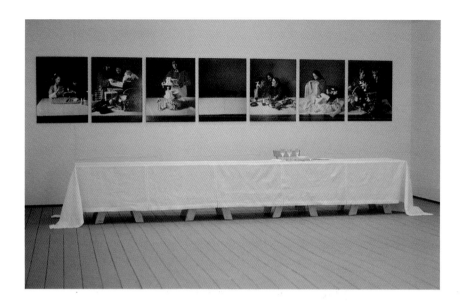

by a real banqueting table with an embroidered white-linen tablecloth. The table and its cloth (which resemble an altar) and the art of embroidery come, historically, from the realm of women in service. In this work, however, women have moved center stage as the actors and celebrants of the sacrament and are no longer merely the servers or the passive congregation.

The place of the female in the Irish mind and of woman in Irish society is continuing to change and this process is key to any understanding of the energy in the work of artists in Southern Ireland who explore the faultline of gender—from the coolness of Abigail O'Brien's large-scale photographic works to the heat of Alice Maher's more organic approach to media and ideas.

Alice Maher makes sculptures, paintings, and, recently, large-scale charcoal drawings that use female images, clothing, and, in particular, hair—real and drawn. *Familiar 1* (Plate 20) comes from an earlier series of works that involve a large-scale painting and an accompanying object or material. This series plays with the ancient idea of the witch's familiar, which was understood to be a stand-in for the Devil.

The idea that the female is automatically feral, which is both a pagan and a Christian concept, is present in all of Maher's works. Strands of flax like cascading woman's hair accompany a painting of a tiny figure of a woman with spiraling hair. The flax behaves like a woman's hair, which, particularly in abundance as depicted in *Coma Berenices* (Plate 17), has always been read as an indicator of wildness or witchery. Another work, *Berry Dress* (Plate 18), is reminiscent of seasonal pantheistic activity in pre-modern communities. It is almost pretty but, when installed high on a wall on a glass shelf, it reveals its insides as a forest of pins holding berries in place and looks like an apparatus of torture. Like *Staircase of Thorns* (Plate 19), the work plays with ideas of pleasure and pain. The installation, or should I say staging, of *Berry Dress* means that both readings are available. Seductive beauty co-exists with aggression, as if one should

Abigail O'Brien
The Last Supper, 1995 (installation view)

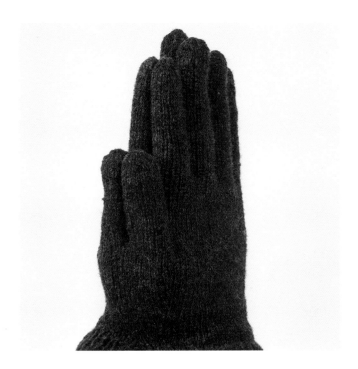

not take anything for granted when exploring this particular faultline, either about the ideas or issues under examination or the art through which they are presented.

Kathy Prendergast also adds a sense of female to a piece that, on first viewing, seems more simply concerned with landscape or land mass. *Stack* (Plate 35), with its contoured layers of blue denim and felt, replicates, on one level, a physical geographical coastal feature—a vertical rock stack with its layers of sedimentary rock revealed by tidal erosion. The sculpture stands above head height, beautifully balanced in its color and form. The layers of horizontal fabric are covered with loose hanging threads, but up close the piece could be a stack of denim material in a clothing factory. In Ireland, certainly, work in such clothing factories has always been women's work. Prendergast also uses maps and mapping—the contouring or measuring of land mass by man, as in one of her earliest works, *Bodymaps*, in which a woman's body is dissected and charted like an area of managed land, which is, of course, man's work.

Prendergast's art manages to be both intimate and general at the same time, and nothing could be more intimate and simultaneously universal than faith. A new work, *Prayer Gloves* (Plate 32), using knitted gloves and photographs, is mysterious until one sees in the accompanying photographs how it forces the user to pray—again, a personal, intimate, but also universal human experience. Prendergast's work crosses the lay lines of land, mothering, gender, and faith with a lightness that keeps her out of the trap of a one-dimensional reading of any of her ideas or subjects. Multiple meanings are conveyed by even her gentlest pieces, in which she often combines human hair with thread or elements of clothing, particularly children's clothing, as in *The End and the Beginning I* and *The End and the Beginning II*.

Kathy Prendergast
Prayer Gloves, 1998 (detail)

Mothering is a key element in Alanna O'Kelly's piece *Sanctuary/Wastelands* (Plate 31). The first version of this work was made in 1992 at a time when O'Kelly had given birth to her second child and when she and the world were watching television images of a devastating famine in Somalia. That period, in the early 1990s, also saw the beginnings of a debate in Ireland about how to read and understand events from our past, such as the Great Famine in the mid-nineteenth century. The Great Famine is a deep-seated trauma for the Irish, a wound in the psyche that became somehow hidden from view but remained a subtext for successive generations, only to emerge as a focus for new open debates in the 1990s. There was simply no way of dealing with the enormity of what happened in the Famine and what was allowed to happen politically. However, O'Kelly comes to the subject through the experience, albeit through the media, of famine in Africa and her own motherhood as well as her Irish identity. The focal point of the projection work is a burial mound on a beach in County Mayo around which one could find human bones before the mound was finally washed away in a storm—closure of a kind that was not lost on O'Kelly. Another version of this work, from 1994, involved the artist running on the spot in the gallery until exhausted, repeating the action of a starving child who ran silently for miles alongside a carriage seeking alms at the height of the Famine.

There is a productive tension in O'Kelly's work between the nature and meaning of the imagery, the experience she creates, and the technological means employed to deliver that experience. O'Kelly maps a landscape of feeling and emotion and, like Alice Maher, employs a vocabulary in art that mixes a haptic approach with Modernist rationality, but her practice insists on meaning being felt rather than explained.

Fionnuala Ní Chiosáin
Untitled, 1993 (detail)

Fionnuala Ní Chiosáin's paintings, such as *Modern Nature #4* (Plate 23), have, until now, been non-figurative or non-descriptive. Her recent work, however, includes some elemental figuration, sections of which are transformed or disfigured by the painting process itself. The recent works on paper are speculative and seem to be the beginning of a new direction—a move on from her exquisite traces of the act of painting, where forms emerge from the behavior of the paint and ink, which appear free to run and stain (Plates 24–27). In Ní Chiosáin's work, however, these actions are disciplined and tightly controlled and settle on the surface as a state or perfectly pitched mood, not a narrative.

In contrast to Ní Chiosáin's, the paintings of Mark Francis, while similarly controlled, are based on the internal territory of the body and are full of incident and the blur of movement. His paintings *Undulation (Indian Yellow)* (Plate 8) and *Nucleus Restriction* (Plate 11) owe much to the current focus on the internal processes of the body, but they also owe much to the new dispassionate photography in Europe as well as to such painters as Gerhard Richter, who inspired much of that lens-based work. It is as if Francis is engaged in reporting the facts and giving evidence, concerned with truth on a micro scale which is capable of expansion to a macro scale. His interest in fungi has led him to explore a real world but beyond or below normal sight, where nothing is right or wrong in itself. It just is or, rather, it just does. A virus grows. An AIDS virus does not know that it is an AIDS virus yet its behavior on one level as a "normal" part of an inevitable natural process is catastrophic on the human level.

The externalized social consequences of such processes are dealt with by Billy Quinn. Quinn spent twenty years in New York making a living in non-art activities while continuing

Billy Quinn
Quinn's Da, 1997 (detail)

to work with photography and particularly with the realities of AIDS in the context of his own life and experience. *Billy* (Plate 36) is one of a series of photographic works overlaid with gold leaf and with the outward celebratory feel of an icon in which he seems to be cataloguing his male and female friends and himself, at a time when people had to come to terms with the blunt reality and finality of death.

Quinn left Ireland at a time when huge numbers of younger Irish people felt driven out by a social, political, cultural, and religious climate that made it impossible for them to have the lives in Ireland that they wanted. He felt able to return to a different Ireland recently, an Ireland with accelerating economic growth, with changes having taken place in social legislation affecting behavior, accompanied by fundamental change in the attitude and status of the Church. Ireland was now a place with which he felt able to negotiate. His relationships with his place of origin and, most importantly, with his family, particularly his father, were part of his own personal re-negotiation. The work *Quinn's Da* (Plate 37) describes and embodies that relationship and represents the space between the two individuals, as if the fires between father and son, which perhaps had previously been present domestically, were no longer burning.

The darkness in Ciarán Lennon's works comes not from a cataclysmic view of social reality but from within a practice that originally involved substantial interventions and alterations in architectural spaces. In these works, light—natural and artificial—was tightly controlled and manipulated to condition and shape the perceptions and responses of the viewer. "Viewer" is probably the wrong term because one became a participant on entering Lennon's earlier installations. But even Lennon's early works that did not require architectural alterations— such as the piece *Folded/Unfolded (Black)* (which has been remade a few times), involving a folded canvas running across an unaltered gallery space like a curtain—were still concerned with the idea of open and closed perception. That tension, and the sense of space *folded*, is the basis of Lennon's recent paintings. *Hearth*, from the early 1990s, is a forerunner of an ongoing series of large-scale works which are layered and spatial but non-descriptive. The work *1/3/92B* (Plate 12), for example, is non-descriptive but it is not an abstract painting because, first, it is such a concrete object; it admits to its own objecthood without illusion or allusion. Secondly, the painting insists on the necessity of involving the viewer in an architectural setting as part of its function and meaning. A superficial reading of Lennon's work could connect it to a strand of non-representational painting that has merely abstracted the pictorial structures of a tradition of European painting. Lennon's painting is in dispute with art of the surface. His paintings are actually installations in which seeing is a human action and a choice, not a given. The viewer is necessary, and his or her decision to see or not to see is part of Lennon's subject. The result is a merging of the perceptual field of the viewer with the perceptual field of the painting—a merging of figure and ground.

The figure of the artist in the ground of community/society is merged also in the practice of Maurice O'Connell, which involves personal interventions in management processes,

specifically the means by which collective society articulates and modifies its ownership of individual behavior. In recent years he has placed himself in the midst of these management processes in local government contexts in Britain, working through ideas that often never result in object making. His own presence and his engagement and negotiation with the public, which deflect attention from the object, have become an important element of his recent work.

The installation *Never Mind "Kangaroo," Just Answer the Question* (Plate 30) is one of the very few pieces O'Connell has made that functions entirely without his presence in the gallery space. It deals with the fact that knowledge and authority are relative, that they are cultural, and that language can disguise as well as disclose meaning. There is a typical patina of humor, with the blacked-out questions on personality questionnaires and a threadbare stuffed wallaby. The personality test is one of the ultimate forms of what the scientific method claims—that everything in knowable. Even a personality can be mapped through the accumulation of fact. If human personality can be mapped then, of course, everything would be knowable, but O'Connell's piece in this exhibition and his overall practice suggest that this is actually not the case.

If the world is unknowable in any definitive way then its components, the mix of nature, culture, and human experience, can be only temporarily measured, fixed, and understood. One of the defining shifts unique to the twentieth century has been the naming of the unconscious, a mechanism that has informed the deconstruction of Modernist authority on a number of fronts—from Surrealist strategies to the discourse on women and gender in film and cinematic languages that have played such a big part in recent contemporary art. This combination of contemporary concerns with gender and sexuality in art and a startling surrealist combination of material and idea have become a feature of Dorothy Cross's work. *Kitchen Table* (Plate 3), an early work in this context, can be seen as a primary staking-out of the territory, with its folk references of found table and enameled washbowl juxtaposed with the burnt-out silhouettes of sharks and the phallic test-tube and shark teeth positioned underneath. The most recent video work, *Storm in a Tea Cup* (Plate 2), also features a stereo-typical folk image of West of Ireland fishermen at sea in a curragh, which is in fact shot from the O'Flaherty film *Man of Aran*—projected on to a cup of tea complete with willow pattern and lace tablecloth. It is as if nature and culture are trapped in a struggle like the fisherman's struggle with the sea, although, contrary to the fisherman's struggle, it takes place within a domestic scenario.

For a period in the mid-1990s, Cross worked with cow skin and cow udders and covered dressmakers' mannequins, shoes, rugby balls, footballs, and croquet balls in a material which, though problematic because of animal-rights issues, was deployed deliberately as an element of provocation. The phallic shape of the shark teeth and test-tube in *Kitchen Table* is echoed in *Saddle* (Plate 1), in which the seat of a leather riding saddle is covered in cow skin and cow udders. In this cultural statement, the udders are vertical, reversed from their natural position,

making the saddle an impossible object perched on metal legs. Cross's play with ambiguity and the deployment of two unlikely materials/objects, as in many surrealist works, is deliberate and creates a third reading that includes but transcends the first two.

In fact, the artists in this exhibition are all engaged in an exploration of the dualities of the Irish situation, of male and female, of urban and rural, of past and present, of North and South, of Protestant and Catholic, which correspond to increasingly visible tensions in cultural and social processes elsewhere in the world. The overall task is to establish a cultural space in which composite, third readings can be generated that are inclusive and not exclusive of opposites; in which linear, one-dimensional readings of anything of value—from culture, politics, and society, to identity—can be dismantled and reconfigured. It is the historical claims on truth—singular readings of value—in which these artists are either trying to engage in order to transform, or from which they are trying to disengage.

None of these artists operates wholly within the trap of traditional Irish identity codes. They interrogate such codes and, along with other cultural practitioners, are engaged in the process of creating a new speculative culture that interrogates rather than replicates given definitions of value. The speculation represented in this body of work will extend the conversation of other speculative cultures in a continuous negotiation of identity, which, in my view, will be needed for cultural and therefore political and social survival in the next millennium.

Ireland

Fintan O'Toole

1

In May 1897, an Irish Fair was held at the Grand Central Palace on Lexington Avenue, New York. The most popular exhibit was a giant topographical map of Ireland. In a long, rectangular room, surmounted by a huge green shamrock and surrounded by five columned archways, the map was spread across the floor. It was divided into thirty-two parts, representing the exact contours of the island's thirty-two counties. But the special attraction of the map was that each of these "counties" had been filled with "the veritable Irish soil of the county … duly attested as truly genuine." For ten cents, the visitor to the fair could walk the length and breadth of the island. The nostalgic Irish immigrant could feel under foot the land itself, could lean down and touch his native soil.

As the *New York Irish World* newspaper reported, "many a pathetic scene is witnessed daily." One day an eighty-year-old woman called Kate Murphy paid her ten cents, stepped across the coastline and made for her native county, Fermanagh. She knelt down and kissed the soil, "then, crossing herself, proceeded to say her prayers, unmindful of the crowd around her. While thus kneeling, a photographer took a flashlight picture of her. The flash was a revelation to the simple-hearted creature, who seemed to think it a light from heaven, and was awed into reverential silence. When she finally stepped off the Irish soil, she sighed sadly and clung to the fence, still gazing at 'Old Ireland.' She kept looking backward as she walked away, as if bidding a long farewell."

This event has a strange, haunting quality, for although it happened a century ago, it seems to belong so obviously to the beginning of the twenty-first century: to the era of virtual reality (the real soil "duly attested as truly genuine"), of nature turned into culture (an exhibit framed, packaged, and sold to paying customers), of intense personal experiences played out in the artificial glow of camera flashes. Even stranger is the fact that the event anticipates by a full century the preoccupations of many Irish artists now as they grapple with images of a packaged culture, a landscape shaped by human intervention, a people at home in a displaced world but yet haunted by memories, gazing back at "Old Ireland" as they walk away.

2

The Irish have always wanted to be as well-off as anyone else. The things that outsiders tended to admire about the place—its empty spaces, its vestiges of an older culture, its apparent simplicity—were also the things that Irish people wanted to escape. They were marks of failure. If the landscape was empty, it was because famine and emigration had, uniquely in Europe, led to a drastic decline in the population, from eight million in the 1840s to five million in the 1990s. If an older culture survived, it was because the place had been left behind in a double sense, abandoned by the immigrants who could not make a decent living in the country, and

bypassed by the Industrial Revolution. If the way of life was simple, it was because poverty leaves people with little room for variety and complexity.

Far from shunning the modern world, as romantics fondly imagined, the Irish traveled great distances to get into it. At the beginning of the twentieth century, there were more Irish-born people in New York than in Dublin. There were large, and growing, Irish communities in London, Liverpool, Glasgow, Boston, Philadelphia, Sydney, and almost every other English-speaking city in the industrialized world. Irish people have, therefore, been modern city-dwellers for over a century. They just didn't dwell in Irish cities.

The emigrants sent letters and photographs to the folks back home. Images of modern luxury, of modern success, flooded the country in a peculiarly intimate way. Children in small and relatively remote villages wore American clothes sent by their aunts in Brooklyn and Springfield. Women in dingy cottages in Ireland knew all about suburban living in 1950s' America because their sisters sent them pictures of their cars, fridges, and televisions. Modern consumerism was not just an abstract force, out there somewhere on the fringes of conscious-ness; it was a part of the family. It was at once utterly familiar and completely out of reach. And the Irish were desperate to close the gap.

What has happened in Ireland in the past decade is that, in a sense, everyone has become an emigrant, even without leaving home. The entire society has left the old country of traditional Ireland and migrated into the strange, exhilarating, and confusing surroundings of the globalized, post-industrial, post-modern world. Ireland has ceased to be an island off Britain and become a place that seems, culturally speaking, to be in the middle of the Atlantic, half way between Europe and America. Its relationship to both of those continents has become much closer and, at the same time, much more contradictory.

For a long time, to those continental Europeans who thought about the place at all, Ireland had the magic of an endzone, the mystery of things at the very edge. A long European history of romantic longing for the Celtic fringes encouraged the idea that Ireland's real place in Europe was as an antithesis, as the opposite of Europe, the wild, rugged, noble alternative to Europe's urban and industrial heartland. Yet Ireland did not want to be wild, rugged or noble. It wanted to be part of post-war, industrial, prosperous Europe. European affection for Ireland, based partly on the notion that Ireland was none of these things, encouraged the European Union to give it generous assistance towards its transformation. By now, Ireland has achieved its aim of becoming, in economic and political terms at least, a fairly typical European country, untypical only in the sheer pace with which it has pursued prosperity. In fact, membership of the European Community has transformed Ireland from an economic backwater to the "Celtic Tiger," the fastest-growing economy in Europe, with annual growth rates in the late 1990s of over 10 per cent.

If Ireland's relationship to Europe was changing profoundly, so was Ireland's relationship to America. Whereas, until very recently, Irish labor went to American capital in form of mass emigration to the United States, now American capital is going to Irish labor. The direction of

the flow, at least for now, has been reversed: Ireland is not migrating to America; America, in the shape of IBM, Intel, Gateway 2000, and many other US-based multinational corporations, is migrating to Ireland. The Irish economy is, in many respects, a branch of the American economy. Two-thirds of its booming exports come from foreign-owned firms. Almost one-sixth of its gross national product disappears every year as those companies send their profits back home, usually to America.

In the course of all the change, Ireland has taken displacement to new levels, becoming so dislocated that it is hard to say even to what continent it belongs. There has been a kind of divide in the way the Irish have encountered modernity. Institutionally and economically, they deal with the modern world through Europe. Culturally, they deal with it through America and, to a lesser extent, through Britain. If you think of the best-known imaginative expressions of modern Ireland, the movies of Neil Jordan and Jim Sheridan, the songs of U2, the novels of Roddy Doyle, the dance show *Riverdance*, it is immediately clear that the dominant influences they are dealing with come from the West, not the East.

It is no easier to say what epoch Ireland currently inhabits. For what is peculiar about Ireland is that it has become a post-modern society without ever fully having become a modern one. It went from being conservative and rural to being high-tech and global; from scratching a living on a few acres of rocky soil to working in Dublin's gleaming new Financial Services Centre; from excessive religiosity to wild hedonism; from a slow pace of life to a fast, trendy culture; from the pre-modern to the post-modern with only a half-finished project of modernity in between. Ireland is, arguably, the most globalized society in the world. Its economy is almost completely dependent on transnational corporations. Its population is a diaspora spread throughout the English-speaking world. Its political institutions are increasingly integrated with Europe. Yet, even twenty years ago, it stood out for its parochialism, its inward-looking nature, its relative innocence.

And nothing dies. New things arrive; massive changes happen. But what was there before does not really disappear; it just sinks down a little further beneath the surface. Irish culture is sedimentary, with layers of experience and emotion folded on top of each other. Christianity, for example, succeeded in Ireland by adapting itself to the pagan nature religion that was already there, so that holy wells and holy mountains have survived, even to this day, as an integral part of Irish Catholic practice. Likewise, the new secular culture that has arrived in recent years is being grafted on to a religious tradition. And often, change itself seems merely to remove a recent accretion and to allow buried memories to come to the surface. The looser, more tolerant Irish Catholicism that is emerging now turns out to look very like the kind of Catholicism that was prevalent two hundred years ago. The arrival of an urban way of life allows contemporary Irish people to connect in a way that was not previously possible with the experiences of their ancestors who emigrated to the great cities of America and Britain. The American popular culture that is washing over Ireland itself contains memories of the Irish emigrants who helped to shape it. It is not at all accidental that the work of the artists in this

exhibition is so full of layers, so utterly concerned with the way meanings gather and accumulate, so deeply interested in delving beneath surfaces.

3

The most important thing to understand about Ireland, then, is that the Irish have left it behind, that they are trying to find a stable place from which they can glance back and take it all in. Over sixty years ago, when the Irish state was still young and fragile, one of its most important ideologues, the writer Daniel Corkery, tried to define what made Ireland Irish. He came up with three things that were so obvious and solid that no one could dispute their overwhelming presence: "(1) The Religious Consciousness of the People; (2) Irish Nationalism; and (3) The Land." No one could have disputed the inescapable power of these great forces.

The political partition of the island of Ireland in the early 1920s had left, in effect, a Protestant British province in the North, and in the South, the larger part of the island that became the Republic of Ireland, a Catholic Irish state. In the South, religion, in the shape of the Catholic Church, was so pervasive that Ireland supplied not just its own church but much of American, African, Australian, and British Catholicism with priests and nuns.

The importance of Irish nationalism was equally self-evident. The State itself had emerged from a violent struggle for independence from Britain, fuelled by a deep belief that Ireland was a place apart, with its own history, language, culture, and destiny. Nationalism was so powerful that the major political disputes were not between nationalists and others, but between fervent nationalists and even more fervent nationalists.

The land, the soil that Kate Murphy venerated in New York, was an object of both religious devotion and national pride. The Catholic peasantry had wrenched it from the grasp of the old Protestant landlords, creating in the process a society of smallholders fiercely protective of their few acres. Ireland was essentially a rural society, and its towns and cities were regarded with contempt and suspicion. The economy was utterly dependent on agriculture.

Roughly until the early 1970s, Corkery's three pillars of Irish identity were still standing. Ireland was still so Catholic, so saturated with religion, that it seemed closer to Africa or Asia than to Europe. With the outbreak of civil conflict in Northern Ireland, nationalism was, if anything, resurgent. And the Republic was still a largely rural society: it was only in 1971 that a census showed that, for the first time in Irish history, a majority of the population of the Republic was living in towns and cities.

Yet now, facing into the new millennium, that Ireland is completely gone. Irish Catholics are, as Bishop William Walsh put it recently, "hurt, sad, angered, frustrated, fearful and insecure," shocked by child-abuse scandals within the Church and dazed by the pace of change beyond it. The Church's political influence, once overwhelming, is now minimal. In 1998, for the first time ever, the main Catholic seminary in Dublin got no new recruits at all. The Irish still attend church services in unusually high numbers, but their sexual mores and attitudes are now the same as those of other Europeans.

Nationalism is dead. In a referendum in 1998 on the Northern Ireland peace agreement, 94 per cent of voters in the Republic of Ireland and 71 per cent in Northern Ireland approved of the deal. In the process, they dropped the main demand of Irish nationalism—that Northern Ireland be recognized as an integral part of the Irish state. The old nationalist orthodoxy had become by then the domain of a few cranks. And the land has lost its grip. Ireland is primarily an urban society now. Just 10 per cent of the workforce is employed in agriculture. Those who remain are not romantic peasants, but business people who spend much of their time filling out forms for European Union subsidies.

So the essential Ireland, as any intelligent observer would have understood it when most of the current generation of artists was growing up, has disappeared. What remains is something rather like that giant map in the Irish Fair in New York a century ago: the image of a place that is no less resonant, no less capable of inspiring deep emotions, for the fact that it is just the memory of an old world artificially constructed in the middle of a new one.

And those images do resonate. What has happened is that religion, nationality, and land have become languages. Because the Irish no longer live within their embrace, they no longer take them for granted. They have become aware of them as symbols that can be interrogated, manipulated, taken apart, and put back together. They carry great weight, and even great danger, but no fixed meaning. Artists can find the deep grammar that makes these symbols articulate. They can find a fluid syntax within which these categories of Irishness can be made to say new things. Land can be fused with nationality to create a politicized landscape. Religious ritual can be made intimate and sexual, so that it ceases to be the domain of celibate men. Contested places can become imaginative spaces. Traditions can be re-invented.

All that is left of Ireland is an extraordinary openness. Ireland now is not at a crossroads, it is a crossroads, a spot where different kinds of journey converge and collide for an instant, where ideas and experiences resolve themselves for a moment in a certain pattern and then dissolve again, to be replaced a moment later by a different pattern. And yet this is not, for the Irish, quite as disconcerting as it might seem. For it is in some respects a more benign version of something that they have long suffered in a malign way.

For most of its history, Ireland has been a contested space, fought over not just with arms, but also with ideas and symbols. It has always been possible to imagine it in different, sometimes opposite, ways. Often the ways of imagining it—language, symbol, frame of reference, point of view—have become more important than the place itself. And for most of its history, the presence of opposing imaginations has been a source of conflict and cruelty, as well as of richness and complexity.

Now, finally, Ireland may be reaching a point at which it is comfortable with the knowledge that its distinctiveness does not lie in any one way of imagining itself, but in the fact that it is a place forced from moment to moment to imagine itself. It is beginning to understand that movement itself, and not anything fixed or intact, is its identity. It is beginning to enjoy

the freedom of knowing that what is important is not the triumph of any one way of imagining the country, but of the imagination itself.

Irish artists in particular are revelling in that freedom. For them, the collapse of old certainties—of political orthodoxies, religious restrictions, tribal loyalties—has been perplexing and liberating. They find themselves no longer having to define their culture in opposition to Britain, but facing all ways at once—toward a Europe in which Ireland is finding a place, toward the United States with its huge Irish population and its dominant popular culture, and toward the wider developing world with which Irish history has odd and interesting connections. As they move through the labyrinths of the wide world they are bringing a ball of Irish thread with which to find their way back home.

Poetics, Politics, and Irish Art: Thirteen Questions

Poetics, Politics, and Irish Art: Thirteen Questions

Kim Levin

Fintan O'Toole's account of the topographical map created a century ago for an Irish Fair in New York is a tale that touches the chords of the 1990s. Made of genuine soil from Ireland's thirty-two counties, it is an unintentional piece of installation art a century ahead of its time, embodying all the issues that artists around the world have been dealing with recently: dislocation, displacement, migration, diaspora, identity. It even embodied, as O'Toole points out, a kind of virtual reality. This premodern tale of symbolic Irish soil exudes a nostalgia for lost roots that engages neatly with our own post-modern condition of generic, generalized, and sometimes very specific uprootedness. It is an irresistible metaphor not only for a place but also for our peculiarly transitional and unsettled time.

And yet, from the point of view of an outsider, this tale of the Irish map also resonates with a twinge of something that's perhaps a bit too close for comfort to old-fashioned nationalistic sentimentality. Sentimentality is compatible with the post-modern climate. Nationalism, however, is problematic. Attached to the concept of lost homelands, patriotic symbols, and fetishized notions of nation-states, this politicized worship of the ground beneath one's feet may have been an attribute of the nineteenth century, but in the midst of our own fluid *fin de siècle* of internet communications, multinational corporations, collapsed borders, and ethnic cleansing, it is a sometimes lethal anachronism. Artists today are concerned with less circumscribed, less stereotypical issues of the self, involving more porous complexities of sexual, ethnic, and social identity.

However, the reality is that places that have long been contested spaces, or suffered partition, such as Yugoslavia, Israel, Korea, Germany, and Ireland, continue to have a special blood relation to the soil. At least we who look from afar assume that they do. And unfortunately the focus on ethnicity tends to align itself with divisiveness rather than diversity. In these places, the land can become such a powerful territorial and ideological metaphor that it overwhelms all other signifiers of identity—even in the supposedly multicultural and transnational realm of contemporary art.

How do we deal, in this day and age, with the idea that territory can still be equated not only with political ideology, but also with personal identity? In other words, how do we reconcile the old nationalisms, the roots of so much modern evil, with the nomadic post-modern sensibility and new notions of cultural identity?

Some time ago, when the Modernist paradigm ceased to be a viable instrument of belief, it became apparent that all manner of distortions, denials, omissions, and exclusions had been perpetuated within the modern world and the Modernist art world—based on gender, ethnicity, nationality, or geographic marginality. And as artists everywhere began to shed their shared Modernist identity, which was sometimes borrowed

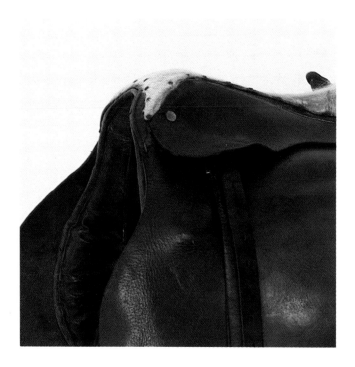

and sometimes imposed, the discourse shifted toward different explorations of cultural identity and a new inclusiveness, as well as an altered awareness of interdependence. In the dialogue between the "regional" and the "universal," the balance of power has shifted toward a more equitable negotiation between "local" and "global." The newest art no longer emanates from a center.

For some years now, much of the most interesting advanced art has come from the former so-called peripheries rather than from the art world's so-called centers. However, even though the universalizing myths and exclusionist practices of Modernism have been replaced by an ambiguously utopian and idealistic focus on multicultural issues of cultural, sexual, and ethnic identity, the innocuous future still collides with a virulent past. And though artists in Ireland and other troubled places may be working not only within the faultlines of a nationalist debate but also with feminist issues, surrealist strategies, genetic codes, and other new issues, it is nevertheless almost impossible to avoid filtering references to their work through the process of nationalism.

While the thirteen Irish artists in this exhibition deal with a broad range of social, formal, theoretical, and gender issues—matters of abstraction as well as representation—how can we explain the irresistible temptation to interpret their work in terms of nationality, however spurious or stereotyped?

On the one hand, the situation is nearly impossible for an outsider to understand. On the other, it may be equally impossible to present a balanced account from

Dorothy Cross
Saddle, 1993 (detail)

within that society. The complexities, complicities, and contradictions are both pervasive and inextricable. In Northern Ireland, the signs of surveillance and conflict are omnipresent, but the borders remain either incomprehensible or invisible, along with the overlapping issues. In the South, a tranquil surface belies hidden scars. Bizarre forms sometimes arise when a sense of identity is divided, conflicted, and tied to a history of mutual victimization.

Dorothy Cross's highly personal and organic mutant objects—phallic nipples, furred garments, cows' udders, snakes (Plates 1–3)—deal with gender, sexuality, and skin as well as the erotics of religion and death. Her mergers of human and animal, of clothing and pelt, connect social rituals and conventions with primal animalistic nature. Because she is an Irish artist, we might also say that her work is concerned with the split nature of her country, or the irrational bestiality of politicized violence. Willie Doherty's impassive photographic and video work (Plates 4–7) leaves no doubt whatsoever that the disrupted tranquil images are very clearly about a politicized and violated landscape, which Doherty has referred to as "a landscape of violence, a landscape of violent nostalgia." In his work—with its vision of traumatized numbness and its textual cues—we might also wonder about the borderline difference between the political and the poetic, the tranquil and the ominous.

Is it possible that the body and the land can be so politicized, so permeated with violence and trauma, that they no longer function as figure or landscape but as disembodied politicized symbols and overriding embodiments of identity? Mark Francis's cellular abstractions (Plates 8–11), based on microbiology and medical photographs of cells, sperms, viruses, and chromosomes, would seem to have little to do with politics or nationality. Their random clusters and linkages of genetic imagery appear to explore old formal issues, proposing a fragile truce between representation and abstraction. But in Francis's work, abstraction is infected with something impure, something that hints, perhaps, at cellular contagion or quandaries created by genetic breakthroughs. We might also imagine—perhaps because we are aware that he is Irish—that his paintings allude poetically to some virulent political virus invisible to the naked eye. Yet this may not be a figment of our imagination, after all. Interviewed in 1997 by Tim Marlow, Francis stated: "The imagery refers to an internal landscape and its mechanisms. ... Cells, bacteria, viruses are all battling it out to win their space and it is this internal struggle that also shows itself outside the body in society."

If we look at the works of the artists in this exhibition in terms of time rather than place, as manifestations of contemporary art rather than Irish art, do our readings of the works change? Ciarán Lennon's paintings (Plates 12–16), less ambiguously abstract, yield little to interpretation. Yet his dark, shadowy surfaces, disrupted grids, inexorable brushmarks, and unyielding flat planes have also been interpreted in terms of scarred poetics and an abstracted politics. As Igor Zabel, Curator of the Museum of Modern Art in Ljubljana,

remarked recently about art in former Yugoslavia, "Universal forms get very different meanings when they enter particular contexts." And as a great deal of recent art around the world has demonstrated, not only geometric or gestural abstraction but also Minimalism, Conceptualism, and other supposedly universal forms can be recycled as containers for new local content.

Can there exist such a thing as an innocuous image? Or, to say it another way, can the works in this exhibition be seen purely for their poetics?

It may not be possible for an innocent image to come out of a place with a troubled history of injustice and strife, whatever the artist's intentions. No image is innocent. Yet sometimes it is hard to know whether a politicized reading of the work comes out of the politics and history of the place where it was made or from within the art object; or whether it is merely some phantom Irish essence, an obfuscating mist arising from the collision of too many external preconceptions and internal expectations ricocheting off each other. Alice Maher's work (Plates 17–20), merging body and land, is consciously permeated by typical, if not stereotypical, Irish materials, substances, and cultural symbolism. Her tiny bee and berry dresses, nettle coat, thorn staircase, briar sphere, cast hair sculptures, and huge hairy wall drawings are imbued not only with female symbolism but also with personal and collective rural Irish memory as well as specifically Irish substances and symbolism.

Mark Francis
Nucleus Restriction, 1995 (detail)

Given an exhibition in which the work of each artist can be (and has been) related, one way or another, to the politics as well as the poetics of a homeland, can we differentiate between earnest and ironic national stereotypes? More important, could we discern their possible absence?

Given the conflicted issues of Irish identity, it may take a while for artists and viewers alike to shed ambiguities and preconceptions. Caroline McCarthy, who says her work is about exclusion and about securing a place in the world, inserts herself abruptly and repeatedly into a typical Irish vista in her video work (Plates 21 and 22). In a deliberately awkward and comic way, this piece makes the point that the artist never quite succeeds in becoming part of the local picture. Fionnuala Ní Chiosáin, using acrylic and Sumi ink (Plates 23–27), universalizes her work by means of a hybrid technique that comes from the East as well as the West. Her liquid images seem to barricade themselves from specifically Irish issues by dissolving into the spectre of past modernisms. And yet, besides alluding to a heritage of abstraction, they convey a sense that the surface is a permeable barrier, coagulating into shadowy figures, walls, or barricades, as if to imply that form as well as content can be politicized.

Could it be that our postcolonial empathy for troubled lands (tied, paradoxically, to unreconstructed cravings for folkloric charm) leads us to seek territorial and ideological meanings that were never intended?

Abigail O'Brien deals with apparently feminist issues in her work (Plates 28 and 29), re-enacting iconic religious imagery from art history in terms of maternal

Ciarán Lennon
1/3/92B, 1992 (detail)

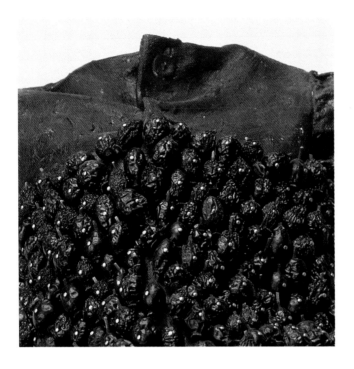

acts and domestic objects. Because we know she comes from a country that is ethnically divided by social and religious rituals and initiations, we find cultural significance in the fact that her photographic installations and sculptural objects reinterpret domesticity, maternity, and religious ritual in terms of initiation into a social order. The social order is an overt concern in Maurice O'Connell's site-specific public projects (Plate 30), which are "driven by a notion of the sense of politics," as he has remarked. The focus of his projects, and their salvaged byproducts, is the notion of citizenry, the nature of public space, and the role of the artist in society and within the political process.

Why should an artwork be expected to carry so heavy and heavily mediated a burden of history and politics?

Alanna O'Kelly's elliptically narrative work (Plate 31), as intimately personal as it is poetic and politicized, alludes to fecundity as well as famine, the richness of memory as well as the history of impoverishment, and the articulation as well as the inarticulateness of communal identity. Says O'Kelly: "I have a passionate attachment to a place, a life, a history." Kathy Prendergast's sculptures (Plates 32–35), like her ongoing series of small neurological "City Map" drawings, seamlessly merge the body and the landscape in a realm of displacement. Luring the eye into unlabeled terrain, her work delineates mental displacements and interrogates the nature of a symbolic attachment to place—in ways that are the precise opposite of the topographical map at the fair long ago.

Alice Maher
Berry Dress, 1994 (detail)

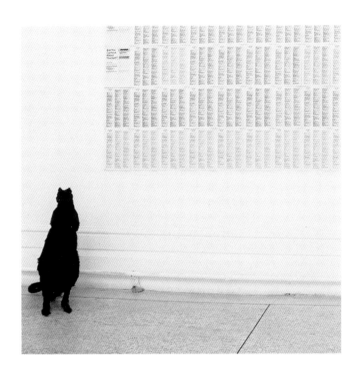

Speaking of content, form, and social issues in art, at what point does the political implode back into the poetic?

Billy Quinn deals with broad issues of sexual orientation, abuse, AIDS, family, and death (Plates 36 and 37). More generally, according to Quinn, they have to do with "our capacity to brutalize each other." And while this capacity in one sense may be general, in this context of Ireland it seems quite specific. Brutality is the subtext, too, of Paul Seawright's photographs (Plates 38–42), which capture the schizoid appearance of normality in a country in conflict with itself. In his various series of photographs, he focuses on disjunctive details that symbolize the clash between visible and invisible insignia of the social order: the deceptively placid sites of factionalist murder, the orange trimmings of Protestant identity, the surveillance devices in a police station, or the security gates and cages that disfigure the doorways of pubs. This is work that carries one meaning if the artist or viewer is Protestant and another if either is Catholic. Conflicting narratives, mutually exclusive histories, and colliding visions of the past and the future are a precondition of split lands.

What actually do these thirteen artists share?

Stylistically, the artists in this exhibition have little in common. In terms of content, they share, perhaps, some equation of land and body, some conflation of the personal and the political, some collapse of the poetic into the unspeakable, some compression of the intimate and the impersonal. And perhaps they share

Maurice O'Connell
Never Mind "Kangaroo," Just Answer the Question, 1995 (detail)

a sense of the incongruities that adhere to a divided place, where a history of brutal acts has long intruded on the bucolic landscape as well as the urban fabric, where tranquil appearances belie a brutalized social body, and where the collective psyche has been split by invisible rifts and faultlines.

The works, temporarily, share another context: that derived from being grouped together in a traveling exhibition of contemporary Irish art. It is this context more than any other that creates an expectation of shared Irishness, however spurious the collective poetics and politics of that divided identity may be.

Who would have imagined that it might be relevant to wonder about the religious affiliations of the artists in this exhibition? Or to wonder whether, if this exhibition had come from Belfast or Derry instead of from Dublin, there would be three artists from Northern Ireland and ten from the Republic?

From the Poetic to the Political, however, is only one reading of Irish art, dependent on the vision and taste of one curator, drawn primarily from the collection of a single museum. The goal of this exhibition is not to present a balanced account of Irish contemporary art but an opinionated one. As Declan McGonagle remarks: "Artists are living beyond these questions of nationalism. The task for artists in general and Irish artists in particular is to create third readings."

What is the role and responsibility of art, and is the construction of meaning inherently connected to a place of origin?

The modern world of fixed borders no longer exists, having dissolved along with the old belief in universality. The recent obsession of many artists and curators around the world with issues of migration and uprootedness, and the equal if opposite fixation on the specifics of cultural identity, do not simply relate to personal, cultural, and national histories and current events. These concerns also emit from a profound state of displacement that is less external than internal, less geographical than temporal, less histo-rical than epochal. Consciously or unconsciously, willingly or unwillingly, artists articulate the traumas of a time as well as a place.

In an attempt to expand the problematic and the possibilities, should we perhaps start again by asking where are the outer limits of identity in time as well as place?

Plates

Dorothy Cross

1. **Saddle**, 1993
Saddle, preserved cow
udder, metal stand
$47\frac{1}{4} \times 22\frac{1}{2} \times 22\frac{1}{2}$ inches

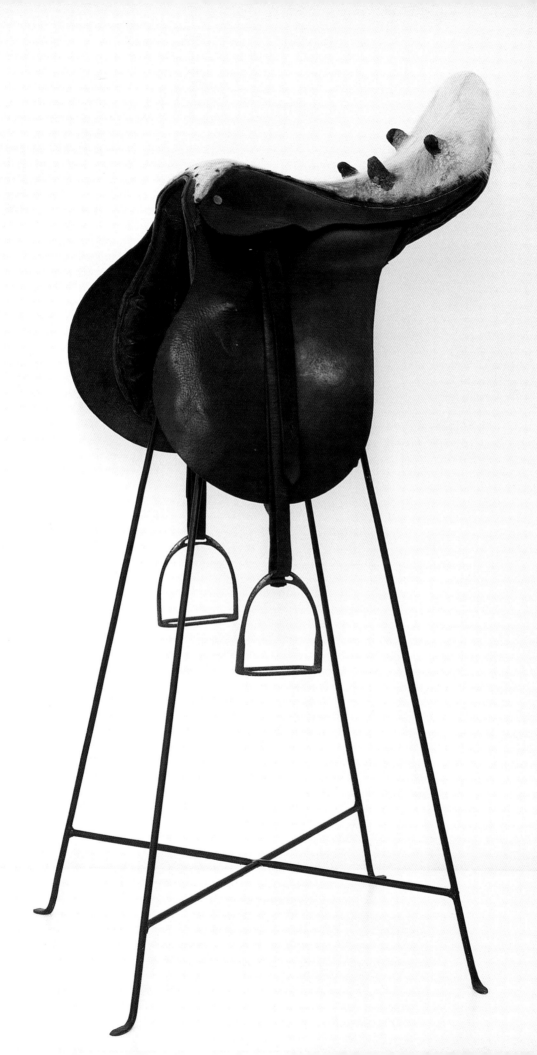

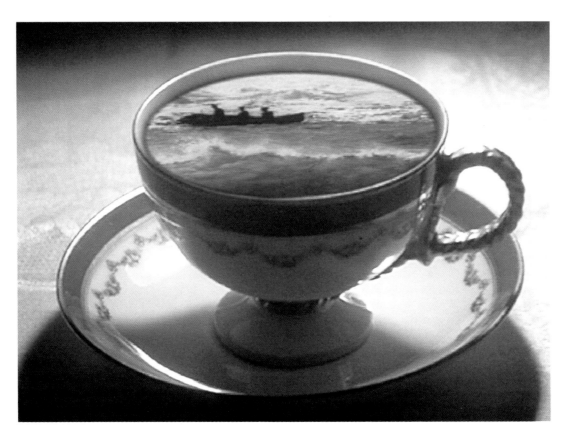

2. **Storm in a Tea Cup**, 1997
Single-channel video

3. **Kitchen Table**, 1990
Wood, enamel bowl, steel, glass
test-tube, fossilized shark teeth
36 × 64 ¾ × 24 inches

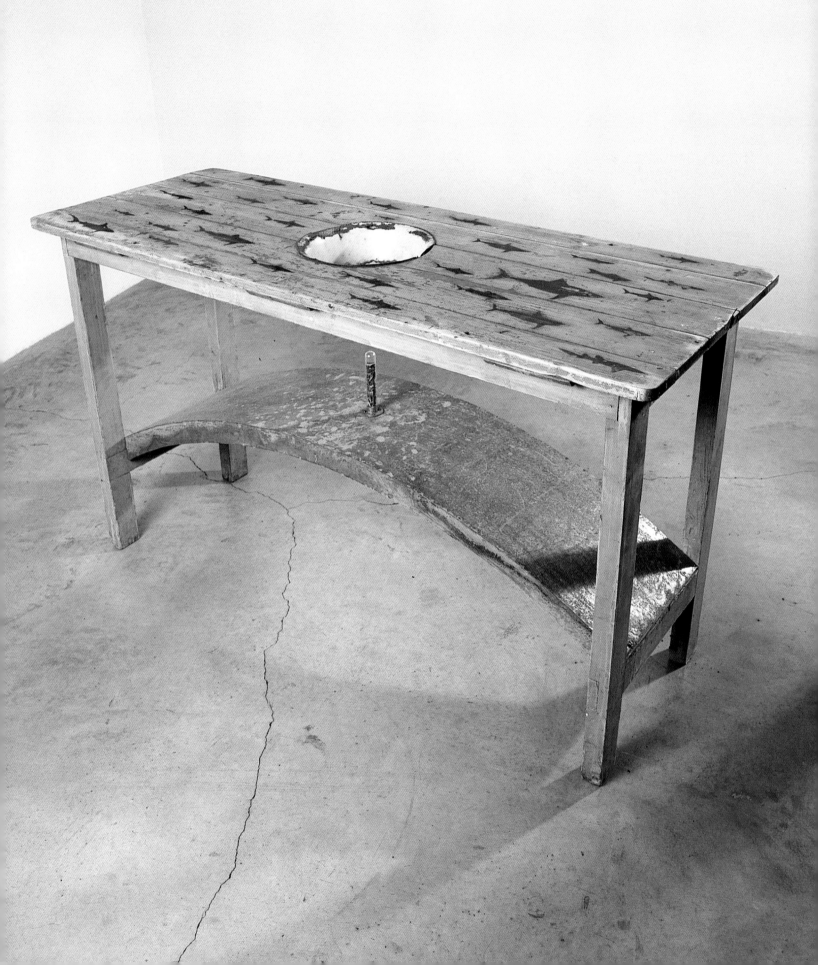

Willie Doherty

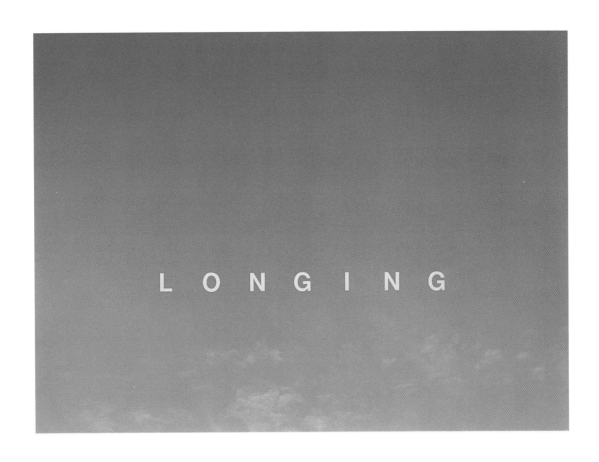

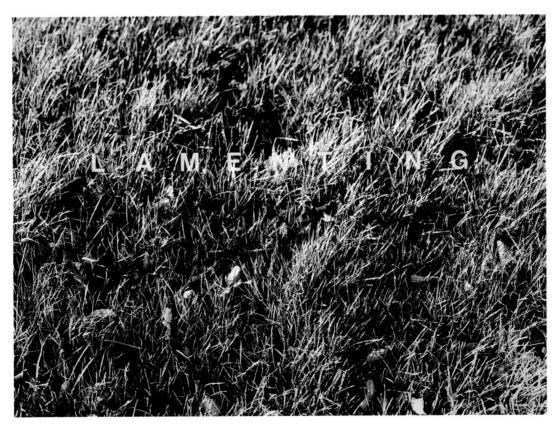

4. **Longing/Lamenting**, 1991
Color photographs with
superimposed text
Two panels, 30 × 40 inches each

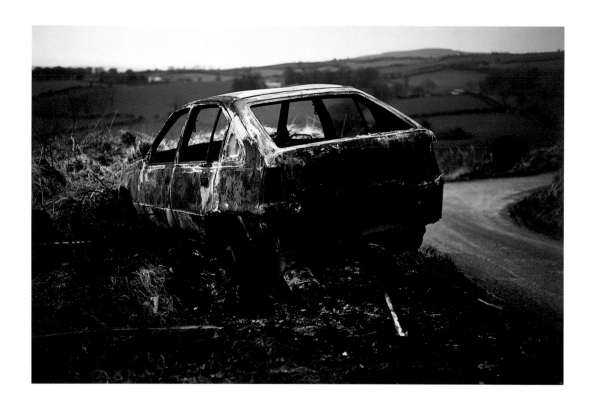

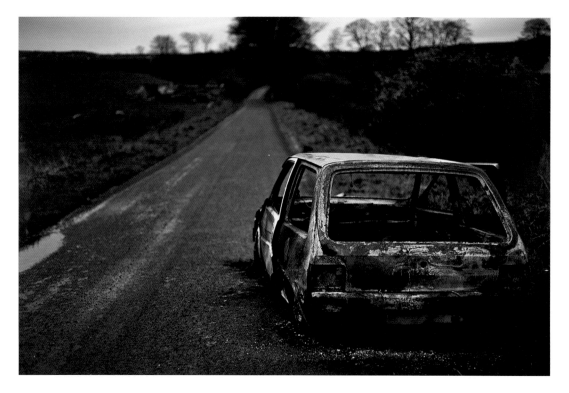

5. **Incident**, 1993
Cibachrome on aluminum
49 1/4 × 73 3/5 inches

6. **Border Incident**, 1994
Cibachrome on aluminum
49 1/4 × 73 3/5 inches

7. **The Only Good One
is a Dead One**, 1995
(video stills)
Video projection with soundtrack
Dimensions variable

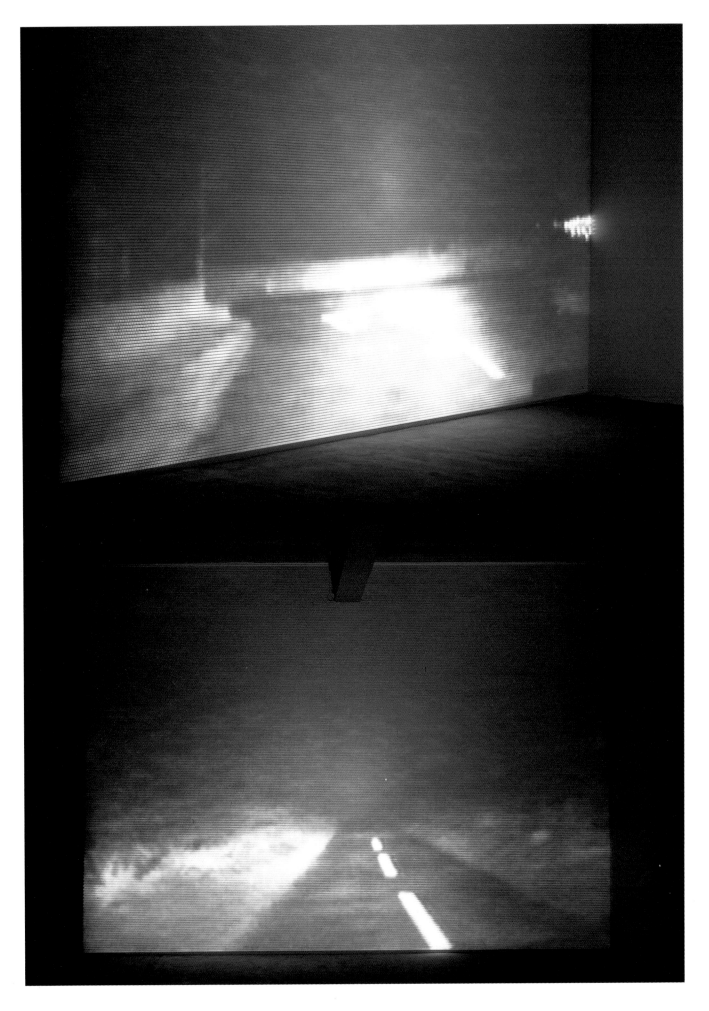

Mark Francis

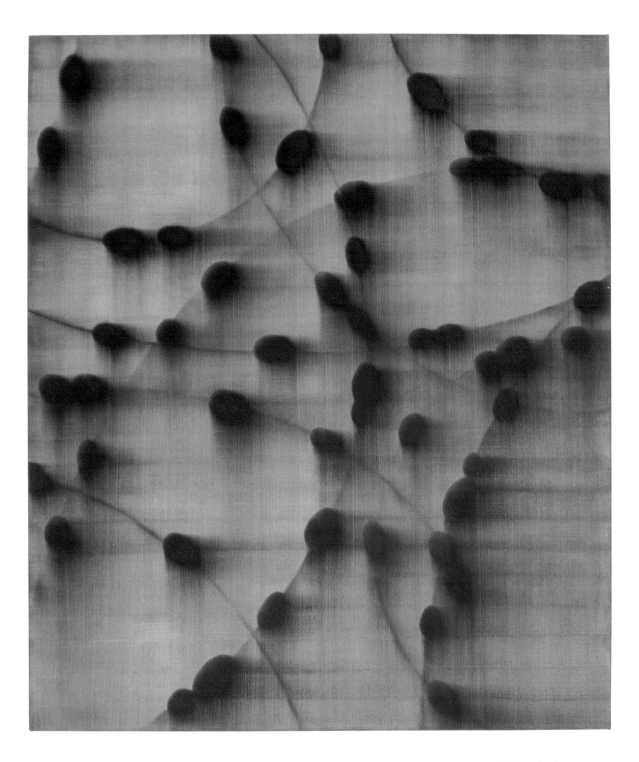

8. **Undulation
(Indian Yellow)**, 1996
Oil on canvas
85 1/4 × 73 1/4 inches

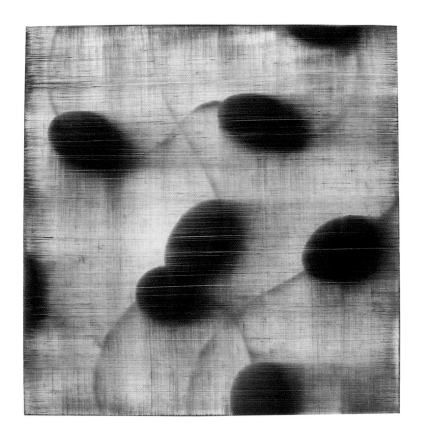

9. **Untitled**, 1994
Monoprint, oil-based ink
on paper
23 1/4 × 23 1/4 inches

10. **Untitled**, 1998
Monoprint, oil-based ink
on paper
31 1/4 × 31 1/4 inches

11. **Nucleus Restriction**, 1995
Oil on canvas
85 1/4 × 73 1/4 inches

12. **1/3/92B**, 1992
Oil on canvas
$97^{3}/_{5} \times 195^{1}/_{4} \times 4$ inches

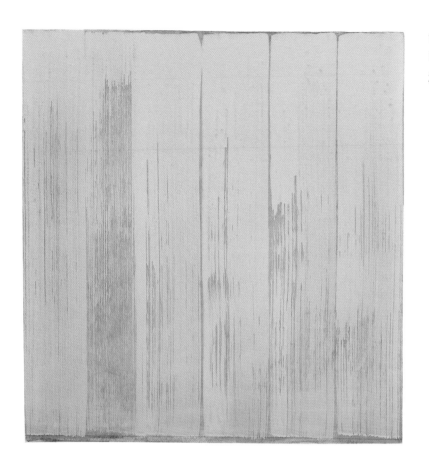

13. **Titanium**, 1998
Gouache on arches paper
30 × 24¼ inches

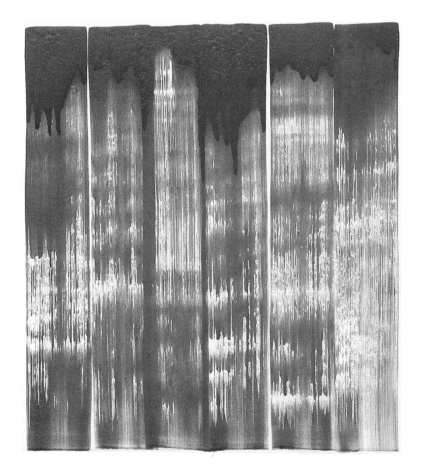

14. **Graphite Grey**, 1999
Graphite paint over titanium
white on arches paper
30 × 24¼ inches

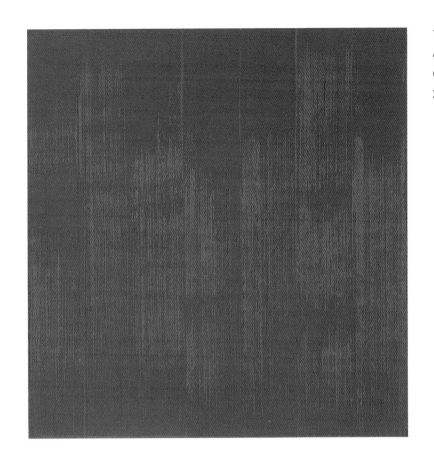

15. **Crimson**, 1999
Acrylic concentrate and
graphite on arches paper
30 × 24 ¼ inches

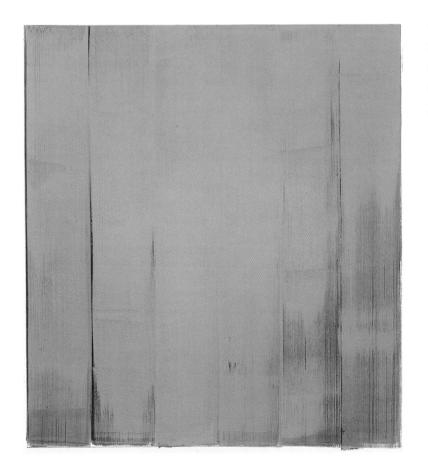

16. **V-Green**, 1999
Gouache, acrylic
concentrate and graphite on
arches paper
30 × 24 ¼ inches

Alice Maher

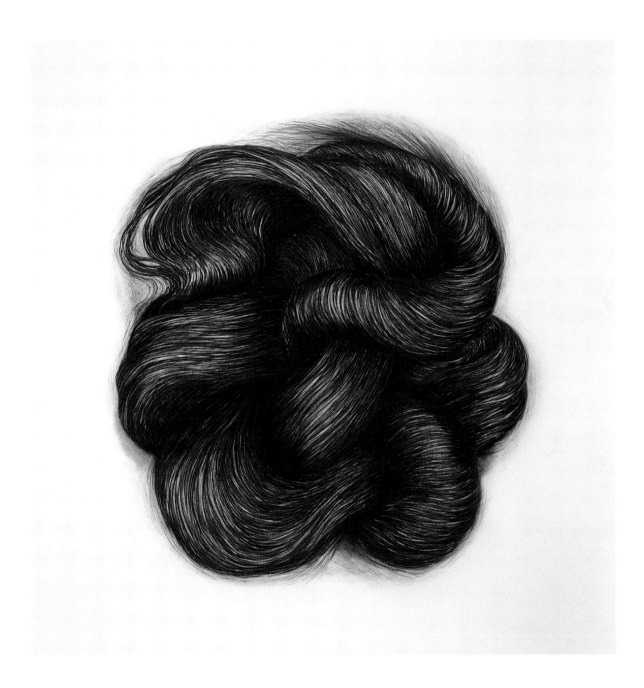

17. **Coma Berenices**, 1998
Charcoal on paper
72½ × 60½ inches

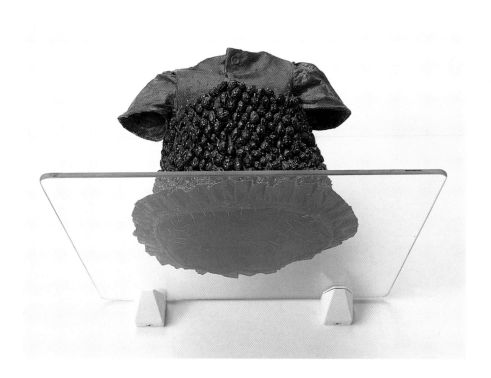

18. **Berry Dress**, 1994
Cotton, paint, rose hips,
and pins
12 × 10 × 6 inches

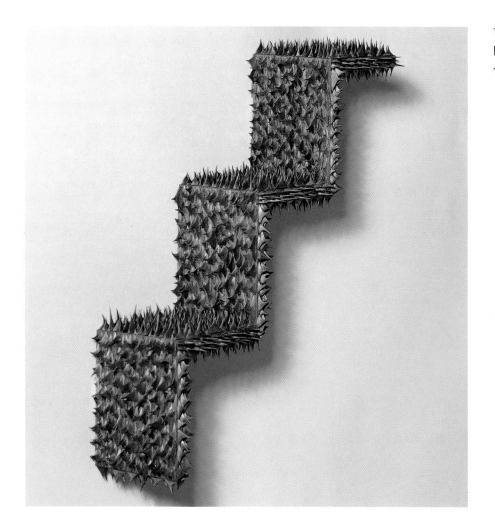

19. **Staircase of Thorns**, 1997
Rose thorns and wood
15 × 15 × 4 inches

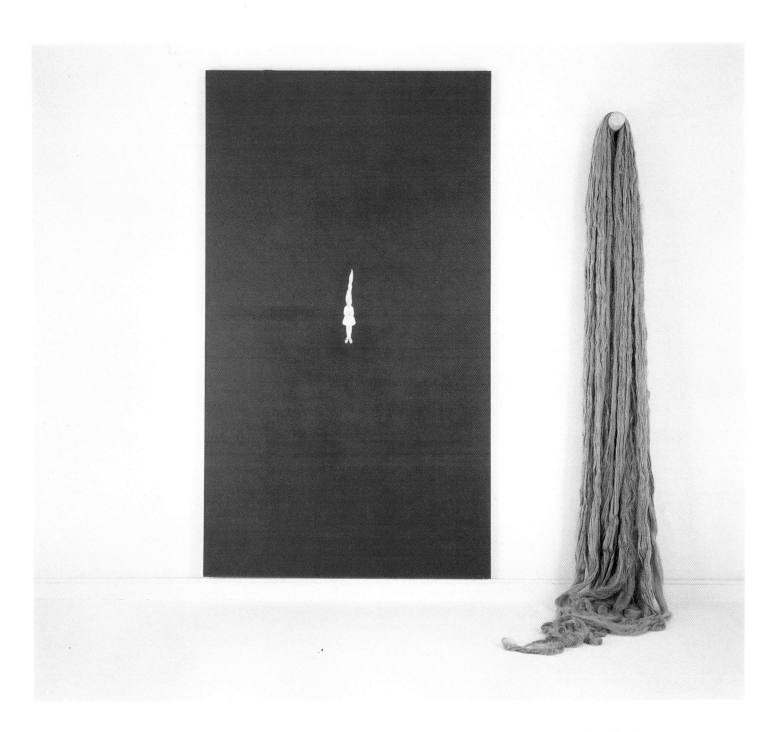

20. **Familiar 1**, 1994
Acrylic on canvas, flax and wood
100 × 100 × 16 inches
(overall dimensions)

Caroline McCarthy

21. **Journey through the Longest Escalator in the World**, 1998
(video stills)
Single-channel video

CAROLINE McCARTHY

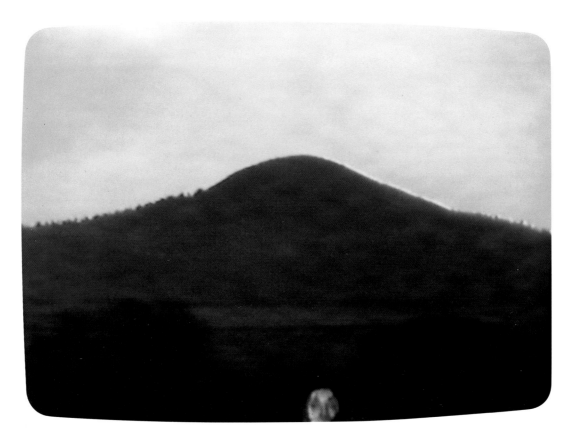

22. **Greetings**, 1996
(video stills)
Video installation with two
monitors on two plinths
Overall dimensions variable 59

Fionnuala Ní Chiosáin

23. **Modern Nature #4**
1993–94
Acrylic and Sumi ink on
paper on wood
60¾ × 48¾ inches

24. **Untitled**, 1998
Sumi ink on paper
40 ³/₄ × 30 ½ inches

25. **Untitled**, 1998
Sumi ink on paper
40 ³/₄ × 30 ½ inches

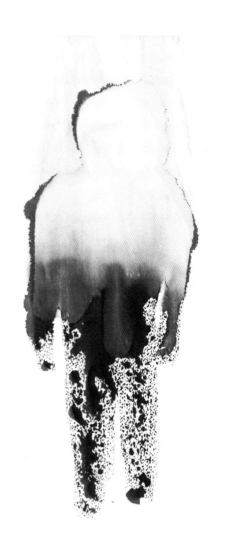

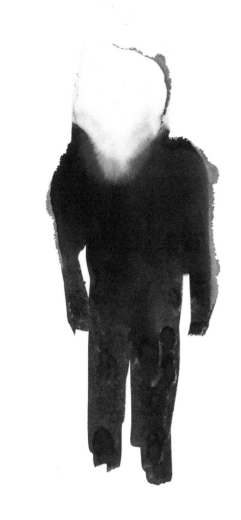

26. **Untitled**, 1993
Sumi ink on paper
20 1/2 × 15 1/4 inches

27. **Untitled**, 1993
Sumi ink on paper
20 1/2 × 15 1/4 inches

Abigail O'Brien

28. **The Ophelia Room**, 1998
(detail)
Three Cibachrome photographs
mounted on aluminum
48 × 50 inches each

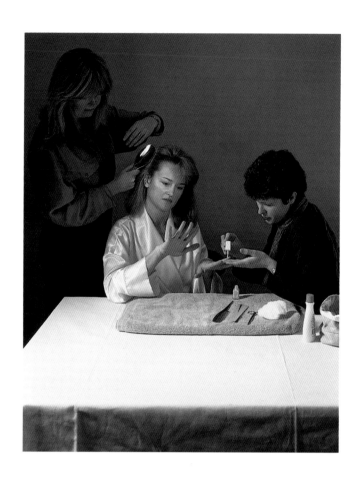

29. **The Last Supper**, 1995
(detail)
Seven Cibachrome photographs
mounted on aluminum, table,
chair, embroidered tablecloth
Photographs: 40 × 32 inches each

Maurice O'Connell

30. **Never Mind "Kangaroo,"
Just Answer the Question**, 1995
Stuffed wallaby and standard
analysis questionnaires
115 paper sheets:
11¾ × 8¼ inches each
(59 × 191 inches overall)
Stuffed wallaby: approximately
32 × 24 × 16 inches

Alanna O'Kelly

31. **Sanctuary/Wastelands**
1993 (video stills)
Slide and audio installation
Overall dimensions variable

Kathy Prendergast

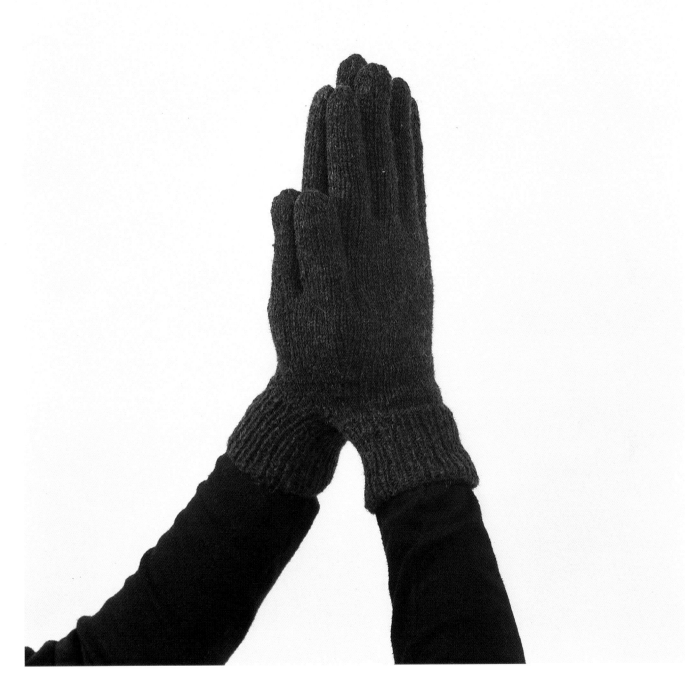

32. **Prayer Gloves**, 1998
Black-and-white photograph
(10 × 8 inches) and a pair of
gloves (knitted together in a
praying-like pose)

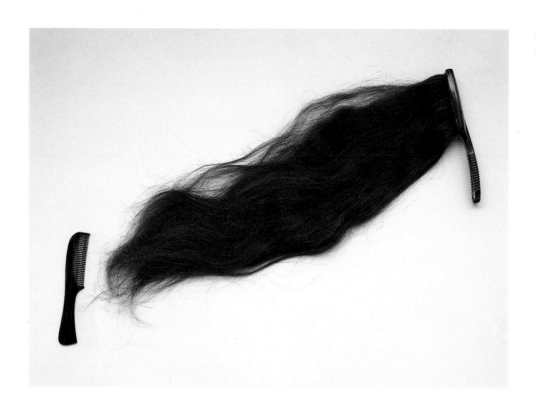

33. **Love Object**, 1999
Brush, comb, and human hair
10 × 2 × 1 inches

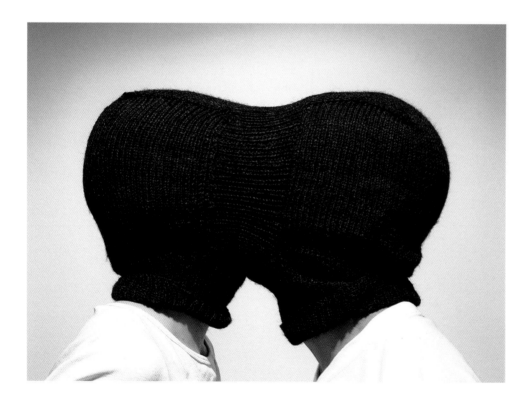

34. **Secret Kiss**, 1999
Two woollen balaclavas
knitted together
18 × 7 × 6 inches

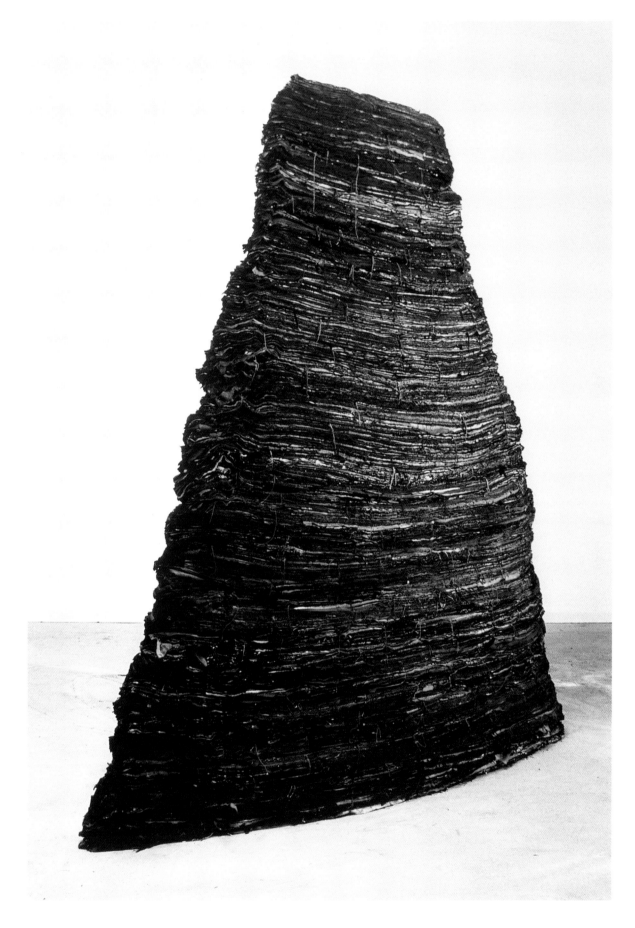

35. **Stack**, 1989–91
Cloth, string, paint, and wood
108 × 104 × 28 inches

Billy Quinn

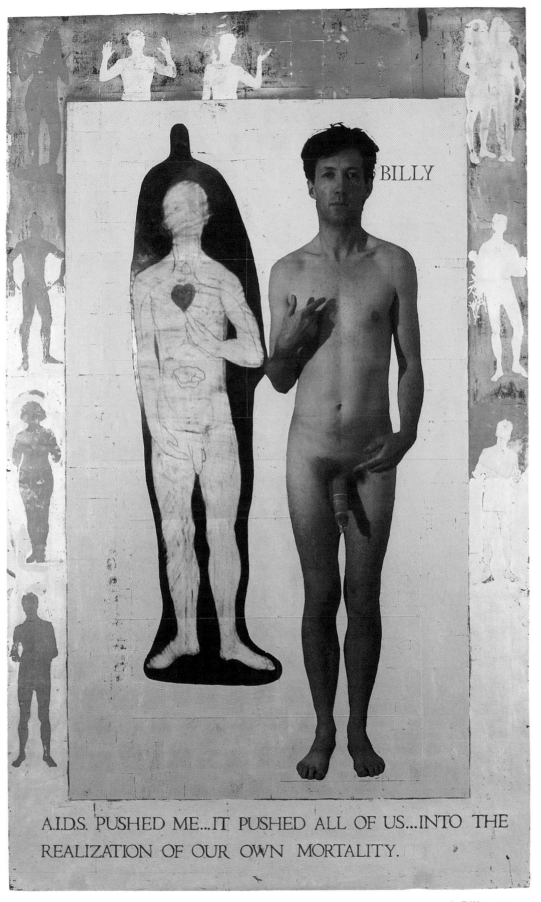

36. **Billy**, 1991
Laser prints, gold and
silver leaf, acrylic on wood
97 1/2 × 60 3/4 inches

37. **Quinn's Da**, 1997
(detail)
Laser prints, mixed media
on plywood/MDF panels
Eleven panels
60 × 60 inches each

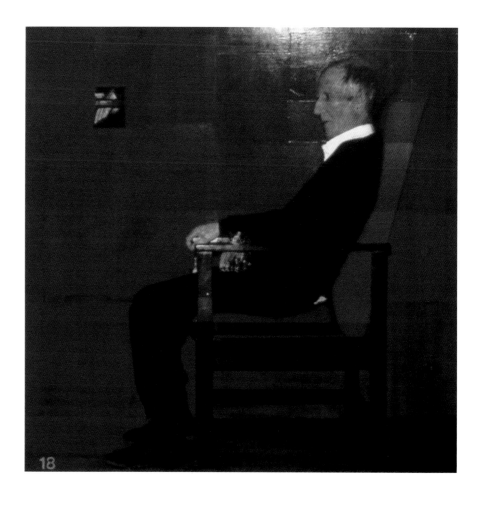

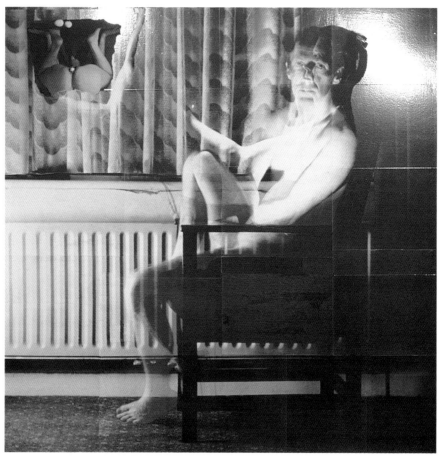

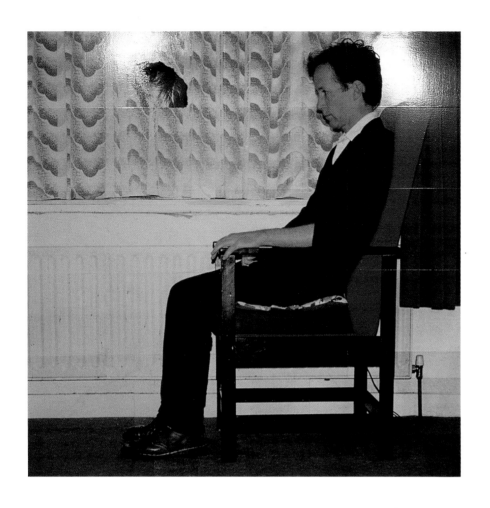

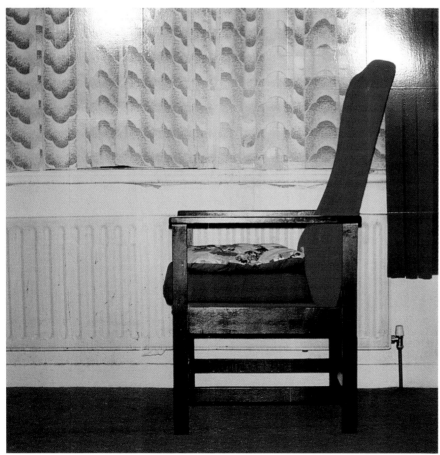

Paul Seawright

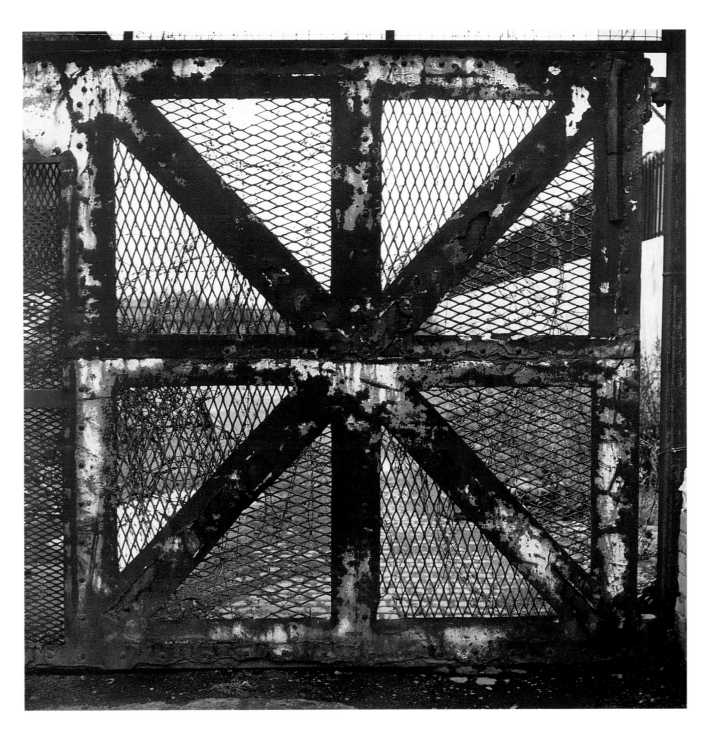

38. **Gate**, 1997
C-type photograph on
aluminum
64 × 64 inches

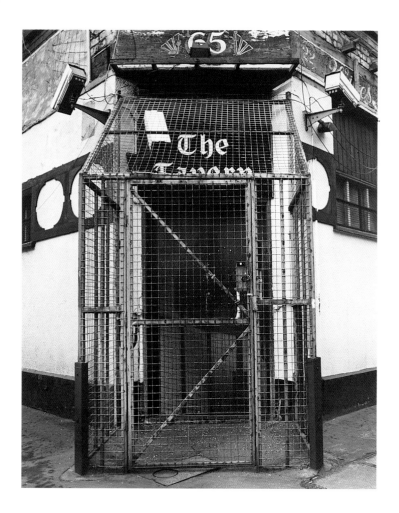

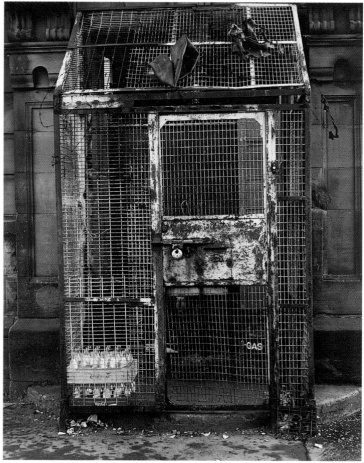

39. **Cage I**, 1997
C-type photograph on
aluminum
80 × 64 inches

40. **Cage II**, 1997
C-type photograph on
aluminum
80 × 64 inches

41. **Flag**

from Fire Series, 1998
C-type print mounted on
aluminum
60 × 60 inches

42. **Black Spike**

from Fire Series, 1998
C-type print mounted on
aluminum
60 × 60 inches

Artists' Biographies

Dorothy Cross was born in Cork in 1956 and lives and works in Dublin. She studied at the Crawford Municipal School of Art in Cork and Leicester Polytechnic in England and later completed a sculpture program and an MFA Degree in printmaking at the San Francisco Art Institute, California. Cross has had one-person exhibitions in Cork, Dublin, Belfast, London, Philadelphia, and New York. She has participated in several international group exhibitions since the 1980s, in particular the Istanbul Bienial; the Center for Contemporary Art, Yerba Buena, San Francisco; the Kerlin Gallery, Dublin; Battersea Arts Centre, London; and the Kid-ai-Luck Gallery, Tokyo. In 1997, Cross was included in *Re/Dressing Cathleen*, an exhibition of Irish women artists at the McMullen Museum of Art, Boston College, Boston. More recently, in February 1999, Dorothy Cross won the Nissan Art Project, Dublin, for her public art piece *Ghost Ship*. In May 1999, Cross created an installation work, *Chiasm*, in a handball alley in Galway, incorporating film and opera.

Willie Doherty was born in 1959 in Derry, Northern Ireland, where he lives and works today. He studied sculpture at Ulster Polytechnic in Belfast. Since the 1980s, Doherty has had numerous one-person exhibitions at the Orchard Gallery, Derry; Matt's Gallery, London; Musée d'Art Moderne de la Ville de Paris, Paris; the Art Gallery of Ontario, Toronto; the Edmonton Art Gallery, Edmonton; and the Arnolfini Gallery, Bristol, among others. His work has been seen in numerous group exhibitions, among them *Critical Landscapes* at the Tokyo Metropolitan Museum of Photography; *Face à l'Histoire, 1933–1996* at the Centre Georges Pompidou, Paris; *Surroundings* at the Tel Aviv Museum of Art, Tel Aviv; and *Act of Seeing (Urban Space)* at the Fondation pour l'Architecture, Brussels. In 1994, Willie Doherty was shortlisted for the Turner Prize, and in 1997 he was included in a major show at the Irish Museum of Modern Art, Dublin, called *Breaking the Mould: British Art of the 1980s and 1990s*. Doherty's work was exhibited at the Kerlin Gallery, Dublin; at Alexander and Bonin, New York; at the Carnegie Museum of Art, Pittsburgh; and at Le Rozel in Normandy, France, in 1999.

Mark Francis was born in Newtownards, Northern Ireland, in 1962. He lives and works in London, having studied at St. Martin's College of Art and the Chelsea School of Art, both in London. He has exhibited widely in Europe and has had several one-person exhibitions in London at the Maureen Paley/Interim Art Gallery, as well as in Manchester at the City Art Gallery; in Dublin at the Kerlin Gallery; and at the Mary Boone Gallery, New York. Francis has participated in many group exhibitions since 1983, namely *Painters' Opinion* at Bloom Gallery, Amsterdam (1995); *Beau Geste* at the Angles Gallery, Los Angeles (1997); and *Sensation: Young British Artists from the Saatchi Collection* at the Royal Academy of Arts, London (1997–98). Francis's work is represented in many international collections, including the Metropolitan Museum of Art in New York and the Tate Gallery in London.

In 1993 he won the Grand Prize at the Tokyo International Print Exhibition. In 1999 his work was included in *0044: Contemporary Irish Artists in Britain* at the Albright–Knox Art Gallery in Buffalo, New York; and *Postmark: An Abstract Effect* at Site Santa Fe, New Mexico.

Ciarán Lennon was born in 1947 in Dublin, where he continues to live and work. He was educated at the National College of Art and Design, Dublin, and began exhibiting his work in the early 1970s. During the 1980s, Lennon's work was presented in many one-person exhibitions throughout Europe, including at the Orchard Gallery, Derry (1980); the Art and Research Exchange, Belfast (1982); Galeri Weinberger, Copenhagen (1988); and Annely Juda Fine Art, London (1989). Among group exhibitions, his work has been seen in *Without Walls* at the Institute of Contemporary Arts in London; *Inheritance and Transformation* at the Irish Museum of Modern Art in Dublin; and *Art Without Expression* at the Fenderesky Gallery in Belfast. Ciarán Lennon was also a participant in the São Paulo Bienal, Brazil, in 1994. Lennon has won many awards, including a Pollock Krasner Foundation Award in 1991 and 1997.

Alice Maher was born in 1956 and lives and works in Dublin. She received her MFA Degree from the University of Ulster, Belfast, in 1986, and in 1987 she received postgraduate training for painting at the San Francisco Art Institute in California. Maher has had one-person exhibitions at the Green on Red Gallery,

Dublin; the Todd Gallery, London; Le Credac, Porte d'Ivry, France; and the Orchard Gallery, Derry. Among numerous group exhibitions, Maher's work has been seen in *Irish Art of the Eighties* at the Douglas Hyde Gallery, Dublin; *Strongholds: New Art from Ireland* at the Tate Gallery, London; *Re/Dressing Cathleen* at the McMullen Museum of Art, Boston College, Boston; and *Art, Grandeur, Nature* at Seine Saint-Denis, Paris. Her work can also be seen in the permanent collections of the Irish Museum of Modern Art, Dublin; the Hugh Lane Municipal Gallery of Modern Art, Dublin; and the Arts Council of Northern Ireland, Belfast.

Caroline McCarthy was born in 1971 in Dundalk, County Louth. Today she works and lives in London. Following the completion of her degree in fine art at the National College of Art and Design in Dublin, she went on to do an MA Degree at Goldsmiths College, London, finishing in 1998. Her work has been seen in many shows around Ireland and, since 1993, in international group exhibitions. McCarthy showed work at the Venice Biennale in 1995, and at *EV&A '96* in Limerick, where she won the Open Award. Exhibitions in 1998 included shows at Cultura Nova, Holland; in Malmö, Sweden; at Temple Bar Gallery and Studios, Dublin; and at the Gallery of Contemporary Art, Warsaw. She was also a participant in the alternative exchange between Australian and Irish artists, *Return to Sender*.

Fionnuala Ní Chiosáin was born in 1966 in Dublin, where she continues to live and work today. She studied

initially at the National College of Art and Design in Dublin and completed her training at St. Martin's School of Art in London. Her one-person exhibitions include shows at Trial Balloon in SoHo, New York; *Modern Nature* at the Kerlin Gallery, Dublin; and the City Arts Centre in Dublin. She has also participated in numerous international group exhibitions since 1989, for example *L'Imaginaire Irlandais* at the Ecole des Beaux-Arts in Paris; and *Idea Europa* in Siena and Padua, Italy. More recently, Ní Chiosáin has participated in *Residue* at the Douglas Hyde Gallery in Dublin; and in 1999 her work was included in *A Measured Quietude* at the Berkeley Art Museum, San Francisco, and the Drawing Center, New York.

Abigail O'Brien was born in 1957 in Dublin and returned to education in 1992. She later attained a First Class Degree in fine art at the National College of Art and Design in Dublin. In 1998 O'Brien completed her MA, again at the NCAD, with a graduation show at the Hugh Lane Municipal Gallery of Modern Art, Dublin. She exhibited at the Venice Biennale in 1995 and at *EV&A '96* in Limerick. O'Brien has won several awards, including the Häagen Dazs Solo Award at Temple Bar Gallery and Studios, Dublin, in 1995 and an Open Award at *EV&A '99* in Limerick. In 1999 O'Brien's work was presented in one-person exhibitions at the Galdic Collection, Rotterdam; and at Krems in Austria.

Maurice O'Connell was born in 1966 in Dublin and currently resides in Dublin and Brussels. O'Connell

studied fine art at the National College of Art and Design in Dublin. Since 1992, his work has been presented in group and one-person exhibitions in Europe and the USA, including *Young Artists in Europe* at La Défense, Paris; *Brothers for Others: Conversations on Culture* in Atlanta, Georgia; *Trust Me I Trust You* at Exchange Resources in Belfast; *Beyond the Pale* at the Irish Museum of Modern Art in Dublin; and at *EV&A '96* in Limerick. More recently, O'Connell has been involved with the performance art group *BlackMarket*, also appearing in their latest show, in April of 1999, at the Green on Red Gallery, Dublin.

Alanna O'Kelly was born in Wexford in 1955. In 1978, she graduated from the National College of Art and Design, Dublin, with a degree in fine art. She then went on to complete a postgraduate course at the Slade School of Fine Art in London. Today she works and lives with her family in Dublin. She has done much performance art and has toured her work in Germany (*Documenta 1967*), Holland, England, Ireland, and the United States. She has contributed to *Eye To Eye*, the Irish Women Artists Festival, in London as well as to the Dublin Film Festival and *Feminalle*, the film and video festival in Cologne, Germany. Her work has appeared in many one- or two-person exhibitions at the Irish Museum of Modern Art, Dublin (1992); the San Francisco Art Institute (1997), and elsewhere. It has been featured in numerous group exhibitions, including *A Sense of Ireland* at the Riverside Studios, London; *4 Performance Artists* at the

Pentonville Gallery, London; *L'Imaginaire Irlandais* at the Ecole des Beaux-Arts, Paris; and *Hors Limites* at the Centre National d'Art et Culture Georges Pompidou in Paris. In 1996 O'Kelly was included in the São Paulo Bienal.

Kathy Prendergast was born in Dublin in 1958. She completed her undergraduate and postgraduate studies at the National College of Art and Design in Dublin from 1976 to 1983 while training as a studio camera operator at RTE (national television and radio). She then went on to the Royal College of Art in London, where she currently lives with her family. Since the 1980s, Prendergast has had one-person exhibitions at the Douglas Hyde Gallery, Dublin; the Camden Arts Centre, London; the Oriel Gallery, Cardiff; the Tate Gallery, London; and Angles Gallery in Los Angeles, among many others. Her work has been presented in major group shows internationally, and in 1995 she represented Ireland at the Venice Biennale and was awarded the Biennale's Best Young Artist Award for her *City Drawings*. Since then, her work has been shown in numerous exhibitions, including *Memento Metropolis* in Copenhagen and Stockholm, *Re/Dressing Cathleen* in Boston, and *Paved with Gold* at Kettle's Yard in Cambridge. In November 1999, a major mid-term retrospective of Prendergast's work will be presented at the Irish Museum of Modern Art in Dublin.

Billy Quinn was born in Dublin in 1954. On completion of his founda-tion course at the National College of Art and Design in Dublin, Quinn emigrated to London, studying at the City and Guilds and later attaining a degree in fine art (film) at North East London Polytechnic in London, where he lives and works today. He has had many one-person exhibi-tions, including *A Plague of Angels* at the Mindy Oh Gallery, Chicago (1993); *Traditional Family Values* at Temple Bar Gallery and Studios, Dublin (1996); the Goldstrom Gallery, New York (1997); and *The Diet of Worms* at the East London Gallery, London (1998). His work has been included in many group shows since the 1980s, in particular *Künstler für die Insel IV*, Frankfurt am Main, Germany (1998); *Out Art* at the City Arts Centre, Dublin (1996); *Condom Project, Castration Project and Various* at Tin Pan Alley Studios in New York (1991); and a two-person show entitled *Art and Architecture Show* at Skidmore, Owen and Merrill in Chicago (1990). In 1995, Quinn returned to Ireland after twenty-two years of absence in order to attend the Artist's Work Pro-gramme at the Irish Museum of Modern Art, Dublin. Today he works as a part-time lecturer in fine art at the University of East London and is currently studying for a professional doctorate in studio practice.

Paul Seawright was born in Belfast in 1965. He lives and works in Gwent, Wales, where he is the MA course leader in documentary photography at Newport School of Art. He did a foundation course at the University of Ulster, Belfast, and went on to complete a degree in film and photography at West Surrey College of Art and Design. He is currently studying part time for a Master of Philosophy Degree (MPhil) at the University of Ulster. Seawright's work has been presented at numerous one-person exhibitions, such as *Police Force*, which toured Europe and the USA in 1996; *Sectarian Murder* at The International Center of Photography, New York, in 1992; *The Orange Order*, which traveled to the Photographers' Gallery, London (1991–93); and shows at the Arts Council Gallery in Belfast and The Gallery of Photography in Dublin. Among the group exhibitions that have featured his work were shows at the Kerlin Gallery, Dublin; Galerie du Jour, Paris; the Nether-lands Foto Institute, Rotterdam; and Houston Fotofest, Houston, Texas. In 1999, Paul Seawright was selected for the third Tokyo International Photo-Biennial entitled *Fragments of Document and Memory*. He also contributed to *Under Exposed*, a public art project in Stockholm, and to *Contemporary Irish Photography*, an exhibition at the Royal Festival Hall in London.

Checklist of the Exhibition

Dorothy Cross

Kitchen Table, 1990
Wood, enamel bowl, steel, glass
test-tube, fossilized shark teeth
$36 \times 64^{3}/_{4} \times 24$ inches
Collection Irish Museum
of Modern Art
Plate 3

Saddle, 1993
Saddle, preserved cow udder,
metal stand
$47^{1}/_{4} \times 22^{1}/_{2} \times 22^{1}/_{2}$ inches
Collection Irish Museum
of Modern Art
Plate 1

Storm in a Tea Cup, 1997
Single-channel video
Courtesy Kerlin Gallery, Dublin
Plate 2

Willie Doherty

Longing/Lamenting, 1991
Color photographs with
superimposed text
Two panels, 30×40 inches each
Collection Irish Museum
of Modern Art
Plate 4

Incident, 1993
Cibachrome on aluminum
$49^{1}/_{4} \times 73^{3}/_{5}$ inches
Collection Irish Museum
of Modern Art
Plate 5

Border Incident, 1994
Cibachrome on aluminum
$49^{1}/_{4} \times 73^{3}/_{5}$ inches
Collection Irish Museum
of Modern Art
Plate 6

**The Only Good One
is a Dead One**, 1995
Video projection with soundtrack
Dimensions variable
Collection Irish Museum of Modern
Art, on loan from the Weltkunst
Collection
Plate 7

Mark Francis

Untitled, 1994
Monoprint, oil-based ink on paper
$23^{1}/_{4} \times 23^{1}/_{4}$ inches
Collection Irish Museum
of Modern Art
Plate 9

Nucleus Restriction, 1995
Oil on canvas
$85^{1}/_{4} \times 73^{1}/_{4}$ inches
Courtesy Kerlin Gallery, Dublin
Plate 11

Undulation (Indian Yellow), 1996
Oil on canvas
$85^{1}/_{4} \times 73^{1}/_{4}$ inches
Collection Irish Museum
of Modern Art
Plate 8

Untitled, 1998
Monoprint, oil-based ink on paper
$31^{1}/_{4} \times 31^{1}/_{4}$ inches
Courtesy the artist
Plate 10

Ciarán Lennon

Hearth, 1990
Oil on linen
$96 \times 8 \times 4$ inches
Collection Irish Museum
of Modern Art

1/3/92B, 1992
Oil on canvas
$97^{3}/_{5} \times 195^{1}/_{4} \times 4$ inches
Collection Irish Museum
of Modern Art
Plate 12

Titanium, 1998
Gouache on arches paper
$30 \times 24^{1}/_{4}$ inches
Courtesy the artist
Plate 13

Oxide of Chromium, 1999
Gouache and acrylic
concentrate on arches paper
$30 \times 24^{1}/_{4}$ inches
Courtesy the artist

Prussian Blue, 1999
Gouache and acrylic
concentrate on arches paper
$30 \times 24^{1}/_{4}$ inches
Courtesy the artist

V-Green, 1999
Gouache, acrylic concentrate and
graphite on arches paper
30 × 24¼ inches
Courtesy the artist
Plate 16

Crimson, 1999
Acrylic concentrate and graphite
on arches paper
30 × 24¼ inches
Courtesy the artist
Plate 15

Graphite Grey, 1999
Graphite paint over titanium white
on arches paper
30 × 24¼ inches
Courtesy the artist
Plate 14

Alice Maher

Familiar 1, 1994
Acrylic on canvas, flax and wood
100 × 100 × 16 inches
Collection Irish Museum
of Modern Art
Plate 20

Berry Dress, 1994
Cotton, paint, rose hips, and pins
12 × 10 × 6 inches
Collection Irish Museum
of Modern Art
Plate 18

Staircase of Thorns, 1997
Rose thorns and wood
15 × 15 × 4 inches
Courtesy Green on Red
Gallery, Dublin
Plate 19

Coma Berenices, 1998
Charcoal on paper
72½ × 60½ inches
Courtesy the artist
Plate 17

Caroline McCarthy

Greetings, 1996
Video installation with
two monitors on two plinths
Overall dimensions variable
Collection Irish Museum
of Modern Art
Plate 22

**Journey through the Longest
Escalator in the World**, 1998
Single-channel video
Courtesy the artist
Plate 21

Fionnuala Ní Chiosáin

Untitled, 1993
Sumi ink on paper
20½ × 15¼ inches
Courtesy the artist
Plate 24

Untitled, 1993
Sumi ink on paper
20½ × 15¼ inches
Courtesy the artist
Plate 25

Modern Nature #4, 1993–94
Acrylic and Sumi ink
on paper on wood
60¾ × 48¾ inches
Collection Irish Museum
of Modern Art
Plate 23

Untitled, 1998
Sumi ink on paper
40¾ × 30½ inches
Courtesy the artist
Plate 26

Untitled, 1998
Sumi ink on paper
40¾ × 30½ inches
Courtesy the artist
Plate 27

Abigail O'Brien

The Last Supper, 1995
Seven Cibachrome photographs
mounted on aluminum, table,
chair, embroidered tablecloth
Photographs: 40 × 32 inches each
Table: 15 feet long
Collection Irish Museum
of Modern Art
Plate 29

The Ophelia Room, 1998
Three Cibachrome photographs
mounted on aluminum
48 × 50 inches each
Courtesy Galerie Bugdahn
und Kaimer, Düsseldorf
Plate 28

Maurice O'Connell

Never Mind "Kangaroo,"
Just Answer the Question, 1995
Stuffed wallaby and standard
analysis questionnaires
115 paper sheets:
11³⁄₄ × 8¹⁄₄ inches each
(59 × 191 inches overall)
Stuffed wallaby:
approximately 32 × 24 × 16 inches
Collection Irish Museum
of Modern Art
Plate 30

Alanna O'Kelly

Sanctuary/Wastelands, 1993
Slide and audio installation
Dimensions variable
Collection Irish Museum
of Modern Art
Plate 31

Kathy Prendergast

Stack, 1989–91
Cloth, string, paint, and wood
108 × 104 × 28 inches
Collection Irish Museum
of Modern Art
Plate 35

Prayer Gloves, 1998
Black-and-white photograph
(10 × 8 inches) and a pair of
gloves (knitted together in a
praying-like pose)
Courtesy Kerlin Gallery, Dublin
Plate 32

Love Object, 1999
Brush, comb, and human hair
10 × 2 × 1 inches
Courtesy the artist
Plate 33

Secret Kiss, 1999
Two woollen balaclavas
knitted together, mounted over
display heads
18 × 7 × 6 inches
Courtesy the artist
Plate 34

Billy Quinn

Billy, 1991
Laser prints, gold and silver leaf,
acrylic on wood
97¹⁄₂ × 60³⁄₄ inches
Collection Irish Museum
of Modern Art
Plate 36

Quinn's Da, 1997
Laser prints, mixed media
on plywood/MDF panels
Eleven panels, 60 × 60 inches each
Courtesy the artist
Plate 37

Paul Seawright

Cage I, 1997
C-type photograph on aluminum
80 × 64 inches
Collection Irish Museum
of Modern Art
Plate 39

Cage II, 1997
C-type photograph on aluminum
80 × 64 inches
Collection Irish Museum
of Modern Art
Plate 40

Gate, 1997
C-type photograph on aluminum
64 × 64 inches
Collection Irish Museum
of Modern Art
Plate 38

Flag, from Fire Series, 1998
C-type print mounted on aluminum
60 × 60 inches
Courtesy Kerlin Gallery, Dublin
Plate 41

Black Spike, from Fire Series, 1998
C-type print mounted on aluminum
60 × 60 inches
Courtesy Kerlin Gallery, Dublin
Plate 42